Canon

EOS *ELAN II/II E*

EOS 50/50E

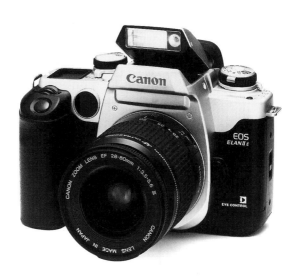

Steve Pollock/Gunter Richter

**Magic Lantern Guide to
Canon EOS ELAN II/IIE**

A Laterna magica® book

Second English Language Edition 1997
Published in the United States of America by

Silver Pixel Press
Division of
The Saunders Group
21 Jet View Drive
Rochester, NY 14624

From the German edition by Gunter Richter
Edited by Steve Pollock
Translated by Hayley Ohlig

Printed in Germany by Kösel GmbH, Kempten

ISBN 1-883403-35-9

Steve Pollock/Gunter Richter
Canon EOS ELAN II/IIE

Contents

Introducing the EOS Elan II/IIE

Once again Canon has introduced a single-lens-reflex (SLR) camera with exciting technical advances. Officially, the EOS Elan IIE (also called the EOS 50E outside of North America) is the successor to the original EOS Elan (or EOS 100). But closer examination shows that the Elan IIE follows in the footsteps of the more upscale EOS A2E (EOS 5)—the world's first SLR with Eye Controlled Focus™. This exciting technology is now contained in a more economical model, which actually exceeds the A2E in some ways.

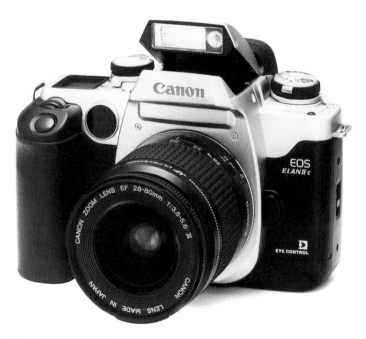

Canon's EOS Elan IIE

The Elan IIE offers every feature the advanced amateur could possibly want, and at a reasonable price. For those on a truly tight budget, the even less expensive Elan II (EOS 50) is virtually identical, except that it lacks the Eye Controlled autofocusing features. Canon certainly did not cut corners on either model. For starters, there are three metering patterns, which can handle any lighting or contrast situation. Every known exposure mode is available, from fully automatic to fully manual, including specialized programs, Shutter-Priority, and Aperture-Priority modes. There's also AE bracketing, plus Whisper Quiet™ film advance and rewind. Even the mirror can be programmed to lock up.

Because of its elegantly simple controls, the Elan II/IIE may appear to be easy to operate. Sure, the basic functions are obvious, but after those are mastered you may still need further information. This *Magic Lantern Guide* is intended as a reference source of easily understandable, comprehensive instruction. To ensure completeness, we have included detailed information about important topics such as flash photography and flash units, lenses and their features, and important accessories. We sincerely hope this book will help you take better pictures—and have more fun—with your EOS Elan II/IIE.

Note: In certain markets, including Europe, the Elan II and Elan IIE are called the EOS 50 and EOS 50E, respectively. Eye Controlled Focus—and everything that goes with it—is available only on the Elan IIE (EOS 50E). In all other respects, the cameras are identical. So unless otherwise stated, everything in this book refers to all versions, which we generically refer to as the Elan II/IIE. The Elan IIE is also available in a QD version with a data back that prints the date or time on the frame.

Important Features

When the EOS A2E (EOS 5) came on the market, it forced a change in photographers' perceptions. It featured Eye Controlled Focus, an amazing new autofocus technology that senses which focusing point the eye is looking at in the viewfinder. The focusing point being gazed at is automatically activated and autofocus is achieved. At the time, it sounded like science fiction, but it worked. Almost

as remarkable was the camera's ability to stop down the lens for depth-of-field preview simply by looking at a specific corner of the viewfinder.

Unfortunately, this attractively simple focusing method worked only in the horizontal format, so it could not be used for vertical images such as head-and-shoulders portraits. With the Elan IIE/EOS 50E (but not the Elan II/EOS 50), Canon has perfected the technique. We now have, for the first time, a camera system that functions whether it is being held in a vertical or horizontal position. The Elan IIE's Eye Controlled Focus works in either situation, making it a far more useful tool. What's more, the system is even more accurate than in the EOS A2E, and twice as fast to boot. We will discuss this topic in detail in a later chapter.

There are other ways in which the Elan II/IIE differs from its predecessors. Its design reflects the popular "look forward, into the past" trend that combines mechanical switches and knobs with electronic controls. This approach allows a great variety of functions and options to be addressed in a manageable way—which is no easy task.

Dynamic AIM (Advanced Integrated Multi-point) exposure metering on the Elan II/IIE coordinates exposure control with the AF system. This way the exposure is optimized for the selected AF area, where the main subject is presumed to be located. Canon has also continued its quest for quiet operation. While the sound of the mirror flipping up is still audible, film transport in either direction is practically silent.

Likewise, advances have been made in flash technology. The 380EX flash, introduced with the Elan II/IIE, offers E-TTL (Evaluative Through-the-Lens) flash. This mode controls fill flash more precisely, blending it with ambient illumination to create a smoother, more uniform lighting effect. Other advanced flash options include second-curtain sync, and flash sync at every shutter speed, up to and including 1/4000 second.

Overview of the EOS Elan II/IIE's Controls

A good way to get acquainted with the EOS Elan II/IIE is by identifying the camera's controls and important components. The numbered item descriptions that follow correspond to the accompanying diagram.

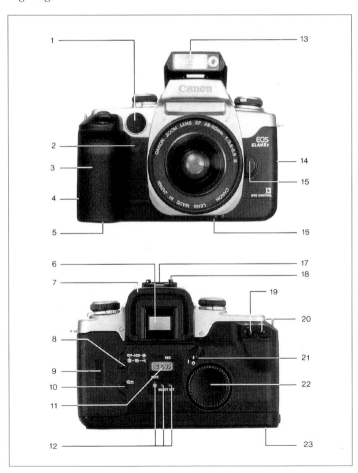

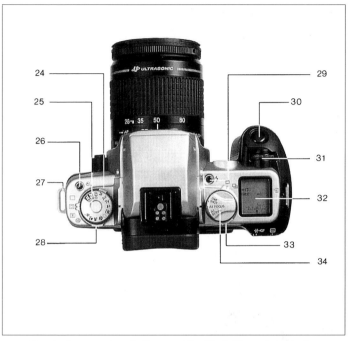

1. AF assist beam emitter/Self-timer indicator
2. Wireless remote control sensor
3. Handgrip/Battery compartment
4. Remote control jack
5. Battery compartment cover
6. Viewfinder eyepiece
7. Eye cup
8. Function button
9. Film check window
10. Film rewind button
11. Date display panel (Elan IIE QD model only)
12. Date imprinting buttons (Elan IIE QD model only)
13. Built-in flash with red-eye reduction lamp
14. Camera back latch
15. Lens release button
16. Tripod socket

17. Flash (X-sync) contacts
18. Accessory shoe
19. AE lock/Custom Function/FE lock select button
20. AF focusing point selector
21. Quick Control Dial switch
22. Quick Control Dial
23. Battery pack positioning hole
24. Command Dial lock release button
25. Command Dial
26. Self-timer/Remote control button
27. Neck strap eyelet
28. Metering mode dial
29. Flash button
30. Shutter release button
31. Main Dial
32. LCD panel
33. Film advance mode lever
34. AF mode dial

Camera Controls

(1) AF Assist Beam Emitter and Self-Timer Indicator

This light-emitting diode (LED) turns on whenever the AF system is having trouble focusing. For example, the main subject may lack contrast, or the light level may be too low. In such a case, the LED projects a deep red pattern onto the surface, allowing the CT-SIR

(Cross-Type Secondary Image Registration) sensor to focus. Although Canon modestly claims a maximum effective distance of 20 feet (6 m), our own tests with an EF 28-105mm f/3.5-4.5 lens in darkness revealed an impressive maximum range of 33 feet (10 m).

The LED also signals the operation of the self-timer. During the first eight seconds, it flashes twice per second (i.e., a frequency of 2 Hz), then during the remaining two seconds it flashes at 8 Hz.

The autofocus assist beam emitter helps the AF sensors find focus in difficult situations, and it also lights up to indicate that the self-timer is active. Directly below it is the wireless remote control sensor, which receives signals from the Remote Controller RC-1 for tripping the shutter from a distance.

(2) Wireless Remote Control Sensor

This sensor receives the signals produced by the accessory infrared remote control RC-1.

(3) Handgrip with Battery Compartment

The designers of the Elan II/IIE made the comfortable handgrip a convenient repository for the power cells and incorporated the shutter release as well.

(4) Remote Control Jack

This terminal accepts the RS-60E3 cable release. The cap provided

to cover the jack seems destined to be lost, so take care of it when you connect a cable release.

(5) Battery Compartment Cover
Located on the bottom of the handgrip, the battery compartment cover is not visible in this illustration. It is opened by sliding the battery compartment cover lever, and snaps shut once the battery is installed.

(6) Viewfinder Eyepiece
The Elan's single-lens-reflex (SLR) viewfinder allows you to look through the lens, right at your subject. The viewfinder's 90% vertical and 92% horizontal image coverage shows what will be included, while providing a small safety margin at the edges. Since you are viewing through the taking lens, naturally there is no parallax, as is found with most viewfinder cameras.

(7) Eye Cup
The large rubber eye cup shields the eyepiece from stray light while providing a comfortable contact surface. Exclusion of stray light is particularly important with Eye Controlled Focus.

(8) Function Button
This controls a wide range of functions: setting film speed, AE bracketing, red-eye reduction, flash exposure correction, multiple exposure, and turning the audible signal on or off. Each press of the button advances the system to the next function, as

The function button on the camera back is used to set the ISO, auto-exposure bracketing, red-eye reduction, audible beeper, multiple exposure, and flash exposure compensation functions. The button below it activates film rewind.

displayed on the back of the camera. Use the Main Dial to select the value for each function, then press the shutter release lightly to store the information. Or, the settings will automatically be stored when the metering system shuts down (four seconds after the last use of any control element).

(9) Film Check Window
This window in the camera's back door reveals part of the film cassette from which you can read the type and speed of the film.

(10) Film Rewind Button
If you want to remove a roll of film that is not fully exposed—perhaps to load film of a different speed—simply press the safely recessed rewind button (with the camera on). Before you do this, however, you should use Custom Function 2, setting 1 (which will read "C02 1" in the LCD panel) to program the camera not to pull the film leader all the way into the cassette. See page 32 for more information.

(11) Date Display Panel
A special back incorporated into QD models allows you to imprint the date and time on images. The LCD shows which data system is selected; if six lines appear, the function is turned off.

(12) Date Imprinting Buttons
These are also exclusive to QD models. They are used to set the date and time, select the style of display, and turn the function on or off.

The EOS Elan II/IIE has a built-in flash and a red-eye reduction lamp. In the Creative Zone modes, the built-in flash is popped up by pressing the flash button. In Full Auto, Portrait, and Close-Up modes, the flash will pop up automatically when required.

(13) Built-in Flash with Red-Eye Reduction Lamp

Press the flash button to pop up the built-in flash and start its two-second charging cycle. The flash symbol appears in the viewfinder to signal that you can fully depress the shutter release to take the shot. To turn the flash unit off, simply push it back down. In three AE modes (Full Auto, Portrait PIC, and Close-Up PIC), the flash automatically pops up when needed. External flash units can also be used, but not in conjunction with the built-in flash.

(14) Camera Back Latch

Press this down to open the camera's back door. But avoid playing with this mechanism or your film will be exposed at an inopportune time—and not the way you intended!

(15) Lens Release Button

Press this button while turning the lens to the left (counterclockwise) to remove it from the camera. When attaching a lens, do *not* press the button.

The large lens release button is conveniently located next to the lens mount. Press it only when removing a lens, not when mounting one.

(16) Tripod Socket

This socket, located at the camera's center of gravity, accepts the standard 1/4"-20 screw of a tripod, copy stand, etc. Very long lenses naturally shift the center of gravity, so most of them are equipped with a separate tripod socket.

(17) Flash Contacts

If you are not using the built-in flash, contacts in the hot shoe electronically connect a dedicated accessory flash unit to the camera. You can thus take advantage of all the automated functions of the camera and flash unit.

(18) Accessory Shoe

This shoe is used primarily for accessory flash units. It can also accept a bubble level to adjust the camera for architectural or copy work.

(19) AE Lock, Custom Function, and FE Lock Select Button

As the description indicates, this button performs various tasks. It takes care of autoexposure (AE) lock (when partial metering is used, for example), calls up various Custom Function numbers (to custom program the camera), and locks the "target" in FE flash photos.

The AE lock button is designated with an asterisk (*). It is also the Custom Function button and the FE lock select button. The button to its right is for selecting a focusing point manually.

(20) AF Focusing Point Selector

Use this button to cycle through the various AF point selection options: left point only, center only, right only, all three, or all three with Eye Controlled Focus (the latter is possible with the Elan IIE only). You can thus optimize the camera for each photographic situation.

(21) Quick Control Dial Switch

The Quick Control Dial should be turned off when you're not using

it, to avoid its being moved accidentally. Setting this switch to "I" turns the dial on; "O" turns it off.

(22) Quick Control Dial
This thumb wheel is a very practical device. In Manual exposure mode, it controls the aperture, which can be changed whether or not the metering system is engaged. In other modes, the dial is used to enter exposure corrections. These corrections can be made only while the metering system is active (within four seconds after you touch the shutter release).

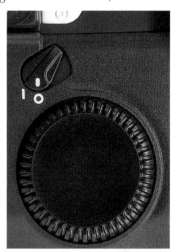

To use the Quick Control Dial, you must first turn it on with the Quick Control Dial switch.

(23) Battery Pack Positioning Hole
A locator pin on the battery pack fits into this hole, ensuring proper alignment with the camera.

(24) Command Dial Lock Release Button
When your hand goes to the Command Dial to turn it from its L (lock or off) position, your index finger ends up right on this perfectly placed release button. You press it automatically, which is *exactly* the way controls should be designed.

(25) Command Dial
The Command Dial is arguably the Elan II/IIE's most important control element. It regulates the various exposure modes and special functions such as calibrating the Eye Controlled Focus system (IIE only) and custom programming. When the dial is set to L, most camera functions are turned off and locked.

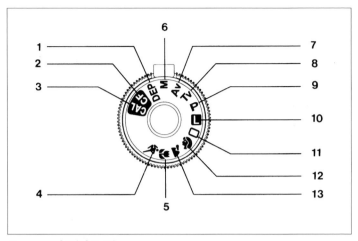

Command Dial Settings

1. **Depth-of-field AE mode (Creative Zone)**
2. **Custom Function setting mode**
3. **Eye Controlled Focus calibration mode***
4. **Sports program (PIC) mode**
5. **Close-up program (PIC) mode**
6. **Manual exposure mode (Creative Zone)**
7. **Aperture-Priority AE mode (Creative Zone)**
8. **Shutter-Priority AE mode (Creative Zone)**
9. **Intelligent Program AE mode (Creative Zone)**
10. **Command Dial Lock**
11. **Full Auto mode**
12. **Portrait program (PIC) mode**
13. **Landscape program (PIC) mode**
 Elan IIE only

(26) Self-Timer and Remote Control Button

Pressing this button once switches the camera into self-timer mode, which is then initiated by pressing the shutter release. The same function prepares the camera for control via the RC-1 infrared remote.

(27) Neck Strap Eyelets

These attachments, located on either side of the camera's top deck, accept the camera's carrying strap.

(28) Metering Mode Dial

This dial is used to select evaluative, partial, or center-weighted metering. It was obviously intended to be moved by using its knurled lever, but we find this awkward. Try pushing it up with your thumb, and down with your thumb and index finger, instead.

(29) Flash Button

Pressing this button pops up the built-in flash and simultaneously turns it on. When you are done with the flash, push it back down to turn it off.

(30) Shutter Release Button

The shutter release button has two positions. Partially depressing it activates the metering and autofocus systems. Depressing it fully makes the exposure.

This precise electromagnetic component operates in two steps. When pressed lightly to the first point of resistance, it turns on the camera's electronic systems. The AF system focuses in a split second, while the exposure metering system determines and sets the required shutter speed and/or aperture. In One-Shot AF mode, all

The shutter release is located where your index finger naturally falls when you hold the camera. The Main Dial is conveniently located right behind it.

values are retained for as long as the shutter release is held in this position. If you release the button by lifting your finger, the settings vanish. Then, pressing the shutter release again halfway will store the data for a new subject or situation.

If everything is okay, press the shutter release the rest of the way down to make your exposure. The Elan II/IIE will then automatically transport the film to the next frame. If your finger is off the shutter release button for a mere four seconds, a power-saving feature turns the metering system off. To turn it on again, gently press the shutter release halfway.

(31) Main Dial
Yet another example of Canon's inventiveness, this vertical dial is a central control element of the Elan II/IIE. In each operating mode, the Main Dial is used to control the user-set variable, such as the f/stop in Aperture-Priority mode. It thus performs a variety of functions (each clearly defined on the LCD panel), with an immediate, positive feel.

(32) LCD Panel
No self-respecting manufacturer would send a sophisticated SLR into the word without one of these. On the Elan II/IIE, it displays information about every possible operating parameter. (See diagram on page 23.)

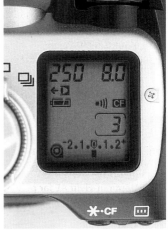

The LCD panel displays information pertaining to your exposure. This example shows the camera's shutter speed and aperture settings. Eye Controlled Focus, beeper signals, and one or more Custom Functions are also active.

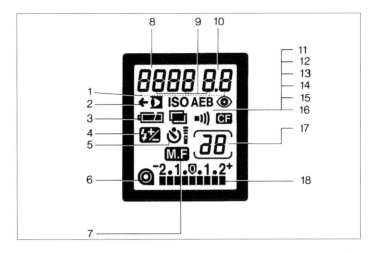

LCD Panel Information Display

Don't be overwhelmed by all the displays shown in this diagram. The LCD never actually looks like this! It shows only the information relevant to the current modes and settings, making the panel easy to read.

1. Eye Controlled Focus activated*
2. Eye Controlled Focus symbol*
3. Battery level indicator
4. Flash exposure compensation
5. Self-timer/Remote control
6. Film status (load/rewind/auto load failure)
7. Manual focus
8. Shutter speed (1/4000–30 seconds, buLb)
 ISO film speed (6–6400)
 Depth-of-Field AE (DEP)
 Custom Function no. (C01–C11)
 Calibration status (CAL, End)*
9. Focusing point indicators
10. Aperture value (1.0–91)
 AE bracketing amount (0.0–2.0)
 Depth-of-Field AE far point/near point (dEP 1, dEP 2)
 Custom Function options (0, 1, 2)

Red-eye reduction (0, 1)
Beeper on/off (0 or 1)
Calibration number for Eye Controlled Focus (1–3)*
11. ISO symbol
12. AEB symbol
13. Red-eye reduction symbol
14. Multiple exposure symbol
15. Beeper symbol
16. Custom Function symbol
17. Frame counter (0–36)
 Number of multiple exposures set/remaining (1–9)
 Self-timer countdown (10–1)
18. Exposure level scale/Exposure level indicator
 Exposure compensation amount
 Flash exposure compensation amount
 AE bracketing increment
 Red-eye reduction lamp on
 Film rewind indicator
*Elan IIE only

23

(33) Film Advance Mode Lever

This is another slightly awkward mechanical lever, best operated by using your thumb and index finger. Use it to switch between single-frame and continuous film advance.

(34) AF Mode Dial

A very handy, old-style switch that selects One-Shot AF (focus priority), AI Servo (continuous focusing with predictive AF), or AI Focus (a combination of the two).

The Viewfinder: The Information Control Center

The Elan II/IIE's reflex viewfinder shows just what will end up on the film—so if you cut someone's head off, you weren't paying attention. Actually, it displays 92% of the horizontal and 90% of the vertical image area, providing some leeway for the vagaries of

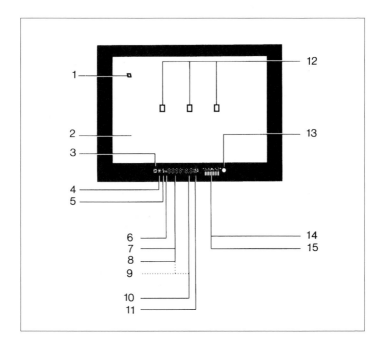

printing machines and slide mounts. Viewfinder magnification is 0.71x with a normal 50mm lens set at infinity.

The eyepiece is set to -1 diopters, which means that if you can see objects clearly at 3.3 feet (1 m), the viewfinder image will appear sharp as well. (Accessory dioptric correction lenses are also available.) Finally, the focal point of the eyepiece is 19.5 mm behind the eyepiece lens, so you can see the whole viewfinder image from this distance. It provides visual comfort for users, including eyeglass wearers.

Viewfinder Information Display

Again, this illustration shows every piece of data that can be displayed in the viewfinder. It does not all appear at once.

1. Depth-of-field preview mark*
2. New laser matte focusing screen
3. Eye Controlled Focus symbol*
4. AE lock indicator
5. Flash ready indicator
 •Glows when flash is ready
 •Blinks to indicate invalid FE lock
6. High-speed sync FP flash indicator
7. Shutter speed (1/4000–30 seconds, buLb)
8. FE lock indicator
9. Calibration indicator (CAL 1–3, End 1–3)
 Far/near point for Depth-of-Field AE program (dEP 1, 2)
10. Aperture value (1.0–91)
11. Flash exposure compensation indicator
12. Focusing points, Partial

metering area
Calibration position (both ends)*
13. AF in-focus indicator
 •Glows when focus is achieved in One-Shot AF
 •Blinks at 2 Hz when focus fails
 •Lights when manual focus is achieved (focus aid indicator)
 •Off when manual focus is not achieved (no focus aid indicator)
14. Film rewind indicator
15. Exposure level indicator
 Exposure compensation amount
 Manual exposure level
 AEB amount
 Red-eye reduction lamp-on indicator
 *Elan IIE only

Getting Ready to Take Pictures

Having learned the basics of the Elan II/IIE's control and display elements, it's about time to start taking pictures. Let's go through the initial procedure step by step.

Loading and Checking the Battery

Insert the battery cartridge with the terminals facing in.

The battery level indicator can display four levels of power:

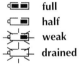 full
half
weak
drained

The Elan II/IIE is usually powered by a 2CR5 6-volt lithium battery. (An alternative is available with the BP-50 and BP-5B battery holders, as we will discuss in the *Accessories* chapter.) Here's the drill:

1. Press the lock on the battery compartment cover and flip it open.
2. Insert the battery cell with the two terminals pointing in towards the top of the camera (follow the diagram on the battery compartment cover). If you put the battery in upside down, with the terminals facing the compartment cover, nothing will operate. Inserting the battery in any other way is impossible, due to the shape of the cell.
3. Close the battery compartment cover.
4. Turn the Command Dial from L to any desired exposure mode.

Data should appear on the LCD panel. If not, the battery is either dead or, more likely, inserted upside down.

5. Check the battery symbol that appears in the LCD monitor:
 (a) If both halves of the symbol are black, the battery is strong.
 (b) If the symbol is only half black, keep a spare battery handy.
 (c) If the half-black symbol is blinking, the battery is in late middle age.
 (d) If the battery symbol is empty and blinking, the end is near. However, you can keep shooting until the shutter release locks. To avoid interruptions, though, it's better to replace the battery while the camera is still functioning.

Battery Power Guidelines

Number of 36-exposure rolls that can be shot per fresh battery.			
Temperature	**No Flash**	**50% Flash**	**100% Flash**
68°F [20°C]	73 (60*)	26 (23*)	13 (12*)
-4°F [-20°C]	33 (30*)	10 (9*)	4.4 (4*)

*Values in parentheses are for the Elan IIE with Eye Controlled Focus in use.

Why are these numbers only guidelines? There is no way to know which functions the camera will use or how long it will use them before you actually press the shutter release—or even decide not to take a picture. But every function uses up power, with the built-in flash heading the list. As a result, the life expectancy of a battery can vary considerably.

Winter use can also reduce the life of a battery, as low temperatures sap battery power. So keep the camera warm between shots. And remember that a battery may give up in low temperatures, yet recover once it warms up again. In any season, keep a spare battery handy, especially if you have a large number of important pictures planned or are heading out on a trip.

Attaching and Removing a Lens

1. To attach a lens, first remove the body cap by turning it to the left (counterclockwise).

2. Remove the lens' back cap by rotating it counterclockwise as well.
3. Align the red dot on the lens with that on the camera, insert the lens, and turn it to the right (clockwise) until it clicks into place.
4. Check the position of the AF/M switch on the lens and set to your preferred mode.

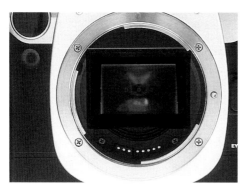

The lens couples with the camera via the EF bayonet lens mount, which transfers information through gold-plated contacts. The contacts should never be touched.

To remove the lens, reverse the procedure. While turning the lens to the left, you also have to hold in the lens release button. Once it is removed, always place the lens down on its front to protect the contacts on the rear of the unit. These should not be touched and should be kept as clean as possible in order to preserve the flow of signals.

Be sure to protect the removed lens by attaching the front and rear caps. The body cap should be in place as well if the Elan II/IIE does not have a lens attached. This is the only way to prevent dirt from entering the camera.

Attaching the Strap

This is a simple procedure, but it may pose problems for some novices who are not familiar with the technique.

1. Pull the end of the strap out of the plastic clasp and feed it through the eyelet on the camera.

2. Feed it back into the clasp.
3. Pull the strap end through the clasp so that it forms a large loop.
4. Feed the end *under* the strap and through the clasp, then pull the strap tight.
5. Repeat the procedure on the other eyelet.

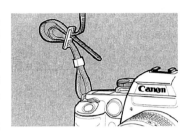

The end of the strap should not stick out too far past the clasp, or it will get in your way.

Correct Handling (Is Half the Battle)

The way you hold the Elan II/IIE determines whether or not your images will be sharp. For clear pictures, the camera must be perfectly steady at the moment of exposure. The slightest wiggle will result in camera shake and blurry photos.

In general, the shutter speed closest to the inverse of the focal length defines the practical limit of the speed you can set for handheld photography. Just imagine a "1/" in front of the focal length to determine the slowest shutter speed that consistently produces good handheld shots. Common examples include 1/60 second for a 50mm lens or 1/250 second for a 200mm telephoto. But these values still depend on proper handling. Hold the camera awkwardly or poke at the shutter release like it was a slab of pot roast, and all bets are off.

Your right hand encloses the ergonomically designed handgrip, with the index finger resting on the shutter release. Place the camera on the palm of your left hand for horizontal shots, encircling the lens' zoom ring with your thumb and forefinger. (Be sure not to touch the focusing ring, which rotates during AF operation.) Please don't try holding the left side of the camera instead of resting it in your left palm. A camera held on the left is unstable. Also this grip doesn't provide you with a convenient way to zoom.

Now practice firing the shutter. This action ruins many shots, as the camera is simply displaced. Here's a better way. Rest your right index finger lightly on the shutter release. Before the expo-

sure, increase its pressure to switch on the metering and focusing systems. To take the picture, just press a little harder without moving your hand. Simply put, less motion causes less vibration.

Finally, your authors disagree on the proper technique for taking vertical shots. GR suggests that you turn the camera so your right hand is on top. Now the left side of the camera rests on the palm of the left hand. SP counters: But how do you zoom? You're better off placing the right side of the camera on the bottom, in your right palm, with your thumb or forefinger on the shutter release. Hold your left palm beneath the lens barrel, with the thumb and forefinger encircling the zoom ring. We agree that you should try both methods and adopt the one you prefer.

Film Loading

Canon recommends the use of DX-coded films, whose cassettes have a checkerboard pattern that allows the Elan II/IIE to set the ISO speed automatically. Almost all current films are DX coded, so that's hardly a limitation. The DX range is ISO 25 to 5000, again offering quite a choice. Manual settings of ISO 6 to 6400 are also possible on the Elan II/IIE, whether or not the film is DX coded.

Note: Infrared films cannot be used with this camera as they will be fogged by the film advance system, which transmits an infrared beam in order to count the number of frames shot.

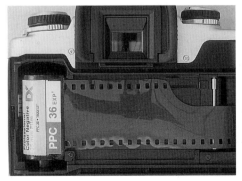

Place the film cassette into the camera, and make sure that the film is lying flat on the guide rails. Then pull the leader over to the orange mark at the base of the take-up spool and close the camera. The film will advance automatically to frame 1.

It's always best to load film in the shade. If none is available, create some by holding the camera in your shadow. The loading procedure is straightforward:

1. Open the back of the Elan II/IIE by pressing down on the camera back latch.
2. Insert the film cassette at an angle, with the protruding end first, covering the spring-loaded nub on the bottom of the chamber. (A diagram in the chamber shows the proper positioning.)
3. Now push the top of the cassette in and rotate it so the felt trap touches the film transport guides.
4. Pull the film leader over to the orange mark on the opposite side. Make sure the film lies flat rather than bulging. If you have accidentally pulled too much film out, remove the cassette and carefully wind the excess back in.
5. Close the back door until it clicks.
6. If the Command Dial is on L, turn it to another setting and the film will automatically advance to the first frame. The LCD briefly displays the selected film speed. Simultaneously, the frame counter moves to 1 and the film symbol appears. These two displays remain visible, even if the camera is turned off, to reveal the film status at a glance.

Caution: *Within the camera's cassette housing are six contacts that read the film's DX coding. These contacts have to remain absolutely clean, so avoid touching them. It is even more important to abstain from touching the vulnerable shutter blades, which are easily damaged.*

If you make a mistake while loading the film (such as not pulling it over to the orange mark), the film symbol blinks in the LCD and no number appears on the frame counter. In that case, just open the camera back and repeat the procedure.

When you first open the Elan II/IIE, you will notice something missing: the cog wheel that most cameras use to transport film. The Elan II/IIE has a much more elegant system, employing an infrared beam to sense the film's perforations and determine how far it is to be transported. This is a real advantage that results in significantly reduced operating noise. As mentioned earlier,

infrared film cannot be used, but for most photographers this is a minor drawback.

Removing the Film
The Elan II/IIE automatically rewinds once the end of the film is reached. This operation makes remarkably little noise, so you don't have to hide in shame at a theater or church function.

As the film rewinds, the LCD display counts down, and the bar retreats toward the film symbol. Once rewinding is complete, the film symbol blinks, and no other symbols are visible. You can now open the back door and remove the film cassette. To do this, grab the film at the *top* end, unclip it, and lift it out of the compartment.

If rewinding speed is more important than silence, Custom Function C01, setting 1 can be set to hurry the process.

Beware if rewinding ceases mid-roll without causing the LCD film symbol to blink. This will happen only when the battery is too weak to complete the operation. Do *not* open the back of the camera, as light will ruin the unprotected film! Instead, turn the camera off, install a new battery, and restart the rewind operation by pressing the rewind button. As soon as the film symbol blinks, the back can be opened. Avoiding this hassle is another good reason to change the battery while it still has some power.

Rewinding Partially Exposed Film
On occasion, the film currently loaded in the camera is not suited to the photographic situation. You therefore need to remove the partially exposed film and replace it with another type. This is not difficult with the Elan II/IIE.

1. Set Custom Function C02, setting 1, so the film leader will stick out of the cassette after rewinding. (Normally the film is rewound completely, but if you leave the leader out, you can later reload the same roll.)
2. Make a note of the last frame number shot.
3. Now press the recessed rewind button to start the rewind operation.
4. When the LCD film symbol blinks, you can remove the film.
5. Write the last frame number shot on the film cassette.
6. Load the new roll as usual.

To reload the partially exposed film:

1. Attach the lens cap, and set the lens' mode selector switch to M. (If no lens is mounted, attach the body cap).
2. Load the film.
3. Set the Command Dial to M, and select the fastest shutter speed (1/4000 second) and the smallest aperture (such as f/22).
4. Press the shutter release until the frame counter has returned to the setting noted on the cassette. Add a blank frame to avoid any chance of partially re-exposing a frame.

Now restore all settings to their normal positions, and you are ready to go again. All this may seem a little complicated on paper, but in practice it takes only a few seconds.

Setting the Film Speed

Every type of film requires a specific amount of light to produce an optimum image. Because we want to shoot under as many different lighting conditions as possible, films are available with different sensitivities, as specified by their ISO values.

The Elan II/IIE's metering system has to know how sensitive the film is that is being used. Otherwise, how would it determine the amount of light the film needs? DX-coded films, as described earlier, allow the camera to sense the film speed automatically. Even so, the Elan II/IIE gives you the option of modifying the DX film speed setting. For example, you may want to "push" a film by purposely underexposing and later compensate by extended development.

These contacts read the film cassette's DX coding.

Here's how to change the ISO setting:

1. Turn the camera on.
2. Press the function button until "ISO" appears on the LCD and the current film speed appears.
3. Turn the Main Dial until the desired speed appears.
4. Touch the shutter release lightly to confirm this setting.

If you load a non-DX coded film, the ISO symbol will flash on the LCD to remind you to set the film speed manually. This can be done over a range of ISO 6 to 6400. Note that a manually entered film speed is wiped out when a DX-coded film is loaded, so that a correction is not carried over from one film to the next. If this does not suit you, select Custom Function C03, setting 1, to set the camera into permanent manual film speed selection mode. Any setting will now remain in effect, regardless of film changes, until it is manually modified.

You can determine what film speed is selected at any time by pushing the function button until "ISO" appears on the LCD.

ISO Film Speed Ratings

The abbreviation "ISO" appears everywhere, on cameras, films, and flash units. It refers to the International Standards Organization, a body that (naturally) sets international standards in many fields. For our use, ISO refers to the agreed-upon method of expressing the sensitivity of photographic materials, specifically camera film.

The ISO standard was intended to combine the ASA designation used in the English-speaking world and the DIN system used in Germany. It starts with the ASA number, followed by a slash and the equivalent DIN number. For example, ISO 100/21° represents 100 ASA and 21 DIN. Over time, the ISO designation has been simplified so that only the first part (the original ASA number) is found on most equipment. This ISO "short form" is the version we employ throughout this book.

Each doubling of the ISO number corresponds to a doubling of film sensitivity, so that half as much light is required for proper exposure. In normal parlance, a film of ISO 100 is considered to be of medium speed, while the high-speed category starts at ISO 400 (being four times as sensitive). The fastest films currently available are ISO 1600 and 3200, although some achieve these ratings only with special "push" processing.

A scene like this demands a lot from your film. It has dark shadows in one half of the frame and bright areas in the other. This example shows the wide exposure latitude of today's films. It was taken with ISO 100 film.

Choosing Film

Many amateur photographers are rather careless about selecting film. They grab any old box off the discount rack without really giving it much thought. You invest a great deal of effort in producing fine pictures—it would be a shame to jeopardize the results because of laziness or to save a few pennies. So please take a moment to ponder your film choice. First, decide whether you want to shoot in color or black and white. (Color is by far the more popular medium, and it will be our emphasis here.) Then choose between having projectable slides, for which you need positive film, or prints, which require negative film. Then you can turn your attention to film speed.

A basic rule is that slower films (low ISO number) have finer grain and greater sharpness than fast ones (high ISO number). Recent advances in film quality have not changed this precept

because films of all types have been improved. So you still should pick slow- to medium-speed film if extra sensitivity is not necessary. In bright light, such a choice provides optimum image quality at a slightly lower cost than a high-speed film. But for low-light or fast-action shots, high ISO films are the only way to go. And luckily for us, their performance is quite good, probably the equivalent of medium-speed films of a few years ago.

Recent Advances in Film

The last few years have brought enormous progress in the field of photo chemistry. Eastman Kodak Company, for example, offers greatly improved emulsion technology based on their T-grain crystals, introduced in 1982. Normal silver-halogen crystals—the building blocks of light-sensitive emulsions—have a cubic, three-dimensional shape. T-grains, on the other hand, are flatter, with a much larger light-absorbing surface. The result is a more uniform emulsion structure, with finer grain and greater image sharpness.

Color negative films have been improving as well. Current films also benefit from T-grains and follow the trend toward delivering stronger colors while retaining good color accuracy, fine grain structure, and high sharpness. The newest color negative films are more tolerant of exposure errors, up to about three stops of overexposure or two stops of underexposure. Within these limits, prints will display reasonable sharpness and color saturation. This does not mean you can become lax about exposure accuracy, because only an optimum exposure will produce an optimum print. Exposure latitude should be regarded as a safety net to catch the inevitable, occasional error.

Exposure tolerance of another kind has also been improved. The new films are just as happy with the extremely short exposure times of modern electronic flashes as with long time exposures. Either situation used to cause color shifts or reciprocity failure (underexposure) with some older films.

Because of today's slow zoom lenses, many film manufacturers now consider ISO 200 to be the standard film speed. As opposed to the previously considered "universal" ISO 100 film, ISO 200 film offers twice as much sensitivity. This is a great help when using the Elan II/IIE with its standard 28-80mm f/3.5-5.6 zoom. The faster film speed increases your flash range by about 40%.

Demanding photographers will want to try the "premium" color

When taking photos in dark locations or indoors without flash, faster films, such as ISO 400, are invaluable.

negative films intended primarily for product photography and other stationary subjects, as ISO 25 is not well suited to general applications unless you have very fast lenses.

The Weak Link

Most amateur photographs are taken on negative film, which then have to be enlarged. In other words, your negatives—as technically clean, sharp, and properly exposed as they can be—must be subjected to another optical and chemical procedure. The results, despite all technical advances, are often disappointing.

Some budget labs pay far too little attention to quality control. Their customers usually don't complain about sloppy focusing, poor color balance, or (God forbid) scratched negatives. These labs' goal is to create cheap, fast prints, and that's what you get.

As a reader of this book, you certainly have aspirations beyond fuzzy snapshots, so be very critical of the quality of your enlarge-

Printing quality can vary from lab to lab. Sending the same negative to two different labs yielded very different results. One lab printed the photo too dark and one print came back from the lab washed out. If you don't

ments. Are they out of focus? Use a loupe to find clear details on your negative, perhaps words or a pattern, and compare them to the prints. If you can read something on the negative that is blurred or unrecognizable on the print, give the enlargements back to be redone.

If your prints have noticeable color shifts—cyan, magenta, or yellow—the lab is usually to blame. Many labs "dial" in too much color, because that's what snapshooters like. But do you really want a picture of Grandma with a pink cast to her face? Virtually all modern films are capable of excellent color rendition if the negatives are filtered correctly in the printer.

Or, Grandma may look inexplicably dark against an undifferentiated field of gray. Here, a bit of technical knowledge is required to assess the density of the negative. If you can look right through it and easily read a newspaper, there is a serious underexposure

like the quality you're getting from your current photofinisher, find one that meets your needs.

problem. It's time to check out the camera or review your shooting technique. Otherwise, the lab has overexposed the print. (Remember, in the printing process, more exposure leads to a darker image and vice versa.)

Sometimes you will find the opposite—prints with washed-out skin tones and blown-out highlights. These may be symptoms of camera overexposure, or of prints from normal negatives that were underexposed in the printer. If in doubt, demand reprints.

If you really want to determine the quality of your camera and lens, try slide film. This material is far less tolerant of exposure deviations than color negative film, and it generally comes back unadulterated, with no intermediate steps for printing. The slide is the same piece of film that was exposed in your camera and fully reveals the capabilities of the camera and lens.

Full Auto and
PIC Exposure Modes

The Elan II/IIE's Command Dial is divided into several areas. Starting in the middle, you have the Lock position (L), and the Full Auto mode (green box), the most basic of several AE modes. Moving clockwise into the dial's (unlabeled) Programmed Image Control (PIC) section, you encounter four specialized AE programs. These are Portrait, Landscape, Close-Up, and Sports AE, each identified by a pictogram of the corresponding subject. Later on we will move counterclockwise around the dial to cover the Creative Zone modes, including Program AE (P), Shutter-Priority AE (Tv), Aperture-Priority AE (Av), Manual (M), and Depth-of-Field AE (DEP) modes.

Full Auto (Green Box)

This program turns the Elan II/IIE into an extremely capable point-and-shoot camera. You just can't go wrong—technically, at least.

1. Turn the Command Dial to the green box.
2. Look into the viewfinder and make sure that the main subject is at one of the AF points.
3. Lightly depress the shutter release. The AF point the camera has chosen to focus with is framed in red briefly. Once focus is successfully achieved, the green in-focus indicator lights at the base of the viewfinder display. The selected aperture and shutter speeds are also visible. In this mode, the built-in flash pops up automatically in low-light situations.
4. Now you can increase the pressure on the shutter release to take the picture.

If the camera is unable to focus, the in-focus indicator blinks and the shutter release locks. Make sure that at least part of the main subject is at one of the AF points and repeat the procedure.

The flash will fire in the Full Auto mode even if the subject is well outside the flash range—with landscape subjects, for

example. To avoid this, simply refrain from using flash with distant subjects. If the flash pops up when you are shooting mountains in the Full Auto mode, push it down manually—without releasing the shutter—to prevent incorrect exposure. The exposure time may be so long, however, that you have to rest the camera on a tripod or other solid object.

In the Full Auto mode, the AF system is set to AI Focus, so it can switch from One-Shot to AI Servo AF when it detects a moving subject. Although the Eye Controlled features of the Elan IIE do not function in Full Auto, all three AF points are active. You can select the red-eye reduction function or the self-timer, and mid-roll film rewinding is also possible. The evaluative metering pattern is always used in this mode.

Basically, the Full Auto program selects the aperture and shutter speed and fires the flash when required. Each of the four specialized PIC (Programmed Image Control) modes performs the same exposure setting functions in its own way. Variables include the selection of single-frame or continuous film advance, flash or no flash, and exposure choices favoring certain aperture and/or shutter speed values. In all PIC modes, the Elan II/IIE uses six-zone evaluative metering. Mid-roll rewind, the self-timer, and the red-eye reduction feature can be chosen (even though the latter is useless in the Landscape and Sports programs, in which the flash is always off).

The Elan IIE's Eye Controlled Focus function is available in all PIC modes, but Eye Controlled Depth-of-Field Preview cannot be used.

Portrait PIC

In classical portraiture, an in-focus subject appears before a soft background, providing visual separation and making the model appear lifelike and three-dimensional. To produce this effect, you need as large an aperture as possible (a small f/number), and a long focal length.

It comes as no surprise that the Portrait program selects a large aperture and whatever corresponding shutter speed is necessary to obtain proper exposure. All you have to do is select or zoom to a longer focal length. Just beware of one potential flaw: If you

choose a telephoto focal length that dictates a long camera-to-subject distance (such as 200mm), the built-in flash will not be effective. Although the flash pops up automatically, it won't be powerful enough to fill in shadows as intended. So move in closer, either by cropping tighter on the model's head or by using a shorter focal length lens.

In the Portrait mode, as in all specialized program modes, the picture-taking process is the same as in Full Auto. The Portrait control settings are somewhat different, however. For example, the One-Shot AF mode is always used, on the reasonable assumption that your subject is stationary. This setting also makes it easy to lock focus onto the most important part of your model, such as his or her eyes. For vertical portraits, you may want to activate only the AF point nearest the top of the frame. On the Elan IIE, Eye Controlled Focus simplifies the focusing point selection process.

Canon also assumes that you want to capture fleeting changes of expression from frame to frame, using the continuous film advance mode. Fortunately, the pressure on the shutter release is so well defined that there is hardly any risk of making unintentional exposures.

As an alternative to this program, you could switch to the Aperture-Priority AE (Av) mode and select a large aperture. This approach allows more flexibility in choosing film advance and AF modes. However, in Av mode you have to keep an eye on the shutter speed to avoid overexposure in bright light.

Landscape PIC

Unlike portraiture, landscape photography usually requires as much depth of field as possible to encompass near and far subjects simultaneously. This is produced by setting a small aperture (large f/number), particularly with wide-angle lenses having relatively short focal lengths. (Stopping down a telephoto lens also increases depth of field, but not enough for most landscape work.)

The Portrait program functions best with longer focal lengths. Such lenses facilitate a shallow depth of field, separating the subject from the completely out-of-focus background. ⇨

The Landscape program selects the smallest possible aperture in order to create the greatest depth of field.

Therefore, the Landscape program selects relatively small apertures when existing light permits. Relatively small doesn't necessarily mean f/16 or f/22, however. The program may select values such as f/8 and 1/350 second—a shutter speed that seems unnecessarily fast for the circumstances. But keep in mind that this program is designed for wide-angle lenses, which suffer from decreased sharpness (due to diffraction) at their smallest openings. While f/16 will bring more of the scene into focus, f/8 will almost certainly render your main subject more crisply.

If you insist on tiny apertures, simply switch to the Aperture-Priority (Av) mode. In the previous example, you might choose f/11 to obtain a little more depth of field. The resulting shutter speed, 1/180 second, is still fast enough for a wide-angle shot.

When the camera's shutter speed display blinks in the Landscape mode, you have a problem. It means that even with the lens wide open (probably creating inadequate depth of field), the required shutter speed is too slow to hand-hold. The flash is turned

off in this program, so pressing the flash button does nothing. One solution is to put the camera on a tripod or other solid base, or you can change film. Press the shutter release as gently as possible, or use the self-timer so you can concentrate on keeping the camera steady.

Landscape photographers tend to be a contemplative lot. Therefore the Landscape program sets One-Shot AF and single-frame film advance.

Close-Up PIC

This program is basically intended for close-focusing zoom lenses, used with three-dimensional subjects such as flowers or small animals. Because it selects relatively wide apertures of f/5.6 or larger, Close-Up PIC is not suited for copy work. (When reproducing two-dimensional objects, you need to set a considerably smaller aperture to counter the lens' natural reduction in performance at the image edges.)

Good photographers create virtue from adversity. In this case the shallow depth of field resulting from wide apertures and short subject distances can be used to create pleasantly blurred backgrounds. Optimum sharpness is found only on the same plane as the main subject, so it is best to avoid near/far compositions.

When necessary, the flash pops up automatically in this mode.

Sports PIC

Although Canon intends this action-oriented program for sports, children can produce just as much motion! In any case, the Sports PIC tries to capture the sharpest possible representation of moving subjects. It does this by selecting the widest available aperture, thus permitting the highest possible shutter speed. The lens is stopped down only enough to prevent overexposure in bright light.

In sports photography, you generally need a telephoto lens to bridge the long camera-to-subject distance. So Canon recommends 200mm or 300mm focal lengths for this program. This is not a requirement, however, because you can also employ short exposure times with shorter lenses.

When shooting fast-paced action, try using the Sports program with the continuous advance mode.

To fully support the program, it's best to use a fairly fast film of about ISO 400. This foresight is, of course, only possible if you know that you will be taking a whole series of action pictures. If you're stuck with slow film in the camera, you may want to take it out and use it up later. This procedure is described on page 32.

When things are happening fast, AI Servo AF is indicated, and that is what the Sports program automatically selects. The center AF point focuses the subject first; if the subject then moves to another AF point, the Predictive autofocus system takes over. With the Elan IIE, you can employ Eye Controlled Focus to help the process along. And because moving scenes tend to require a series of exposures, the film advance system works continuously for as long as the shutter release is pressed.

The built-in flash does not operate in the Sports PIC mode for several reasons. First, sports subjects tend to be beyond its distance range. Second, the 1/125 second sync speed might create "ghost" images in a well-lighted arena. And third, it can't recycle fast enough to keep up with the 2.5 fps continuous film advance.

Multi-Point Autofocus System

The EOS 10s (called EOS 10 outside North America) was the first Canon SLR with multiple AF points distributed across the viewfinder. This useful idea, conceptually similar to the multi-beam AF systems of point-and-shoot cameras, has been carried over to the Elan II/IIE.

In the new models, three (rather than five) AF points are identified by small rectangles in the finder. Canon's BASIS (Base-Stored Image Sensor) cross-type sensor is hidden behind the middle one, enabling the camera to focus on both horizontally and vertically oriented subjects (such as venetian blinds and cages at a zoo, respectively). The sensors on the side are, in effect, extensions of the central point, except they are vertical, not cross-type sensors. They capture main subjects that are located off-center and make it easier to follow moving subjects. These points are sensitive only to horizontally oriented subjects, however.

The Elan II/IIE's three focusing points are located horizontally across the center of the image area. The small Eye Controlled depth of field preview mark is in the top left corner of the Elan IIE only.

Conventional, single-point AF systems are not practical in some common situations. For example, two people may be standing side by side with space between them. Inevitably, the single central AF field slips between them and focuses on the background, rendering the main subjects as a blur. This is a classic problem with point-and-shoot cameras, which generally give you no warning of what's happening. On an SLR, at least you can see the effect

in the viewfinder. Still, such mistakes happen all the time, through lack of skill or inattention.

With the Elan II/IIE, one of the AF points is bound to be on the main subject. And because the AF system focuses on the closest subject, the two people will be in sharp focus, even if the central AF point is measuring the background. A common error is thus eliminated by automation. (Still, a subject that is very far off-center may cause trouble, which is the only drawback to the Elan II/IIE's using three rather than five AF points.) Therefore the photographer is not forced to place the main subject right in the middle of the frame. Such compositions tend to be boring and (for what it's worth) go against all photographic rules. Conventional AF systems avoid these situations by requiring that you use focus lock and perform contortions to recompose, which may cause you to miss the subject's peak moment. Again, the Elan II/IIE's three AF points make this operation unnecessary in most cases—one of them will grab the main subject and focus correctly.

Equally as important, a one-point AF system considerably reduces a photographer's creative freedom with moving subjects. To gain the advantages of Predictive autofocus, you have to keep the subject under the (central) AF point so the system can keep track of its trajectory. The result is a photographic ball and chain. The Elan II/IIE's three AF points, on the other hand, make it possible to photograph a moving subject that is not in the center of the frame. The object is automatically "handed off" from one cell to the next, without the AF system losing track.

So far, the multi-point system offers only advantages. And this is certainly true with moving subjects, or any pictures of mom, dad, or the kids (making the Elan II/IIE an outstanding "family" camera). If, however, you favor landscapes, the three AF points require some attention. In these compositions, the closest detail is often *not* the main subject. But if one of the AF points "reads" the foreground, the camera will focus on it. So you must pay careful

Use a longer focal length lens, like 80 or 85mm, to isolate an interesting ⇨ **subject, such as this neon sign. Be sure to place the subject effectively within the frame so no distracting elements are included in the photo.**

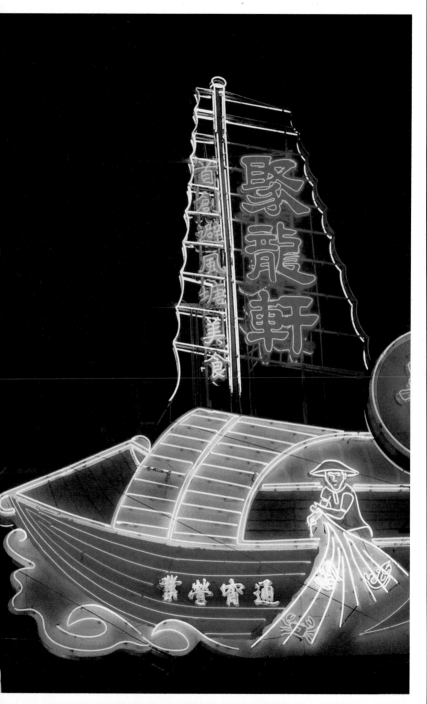

The 20mm focal length is a good choice for taking photographs in close spaces. The Canon EF 20mm USM and EF 20-35mm L lenses both have a maximum aperture of f/2.8, making them ideal for available-light photography. For shooting in poor lighting conditions, using high-speed film—such as ISO 400—is also recommended.

Get close enough so that only the subject fills the frame. Don't give the viewer more visual information than is needed. Shallow depth of field can also be utilized to blur unwanted elements in the photograph.

For difficult lighting situations such as this scene with deep shadows, ▷ bare fluorescent bulbs, and backlighting, use the Elan II/IIE's evaluative metering system and bracket exposures.

If you want versatility without carrying a lot of equipment, bring your Elan II/IIE and a zoom lens. Use a wide-angle setting to capture a scene like this (above). Or, you can achieve a slightly narrower perspective with a longer focal length (left).

attention to which of the AF points glows red, indicating where the camera has focused. We will discuss shortly how you can remedy the problem.

You should also note that the AF system provides valuable input to the exposure system, as is explained in the chapter on exposure metering.

Selecting the Autofocus Point(s)

Up to now, we have assumed that all three AF points are active, and that the camera chooses which of them to use for focusing. This mode is perfect for candids of people, for example. But if several subjects are standing at various distances from the camera, the closest one will become the point of focus, even if you wanted a completely different person to be the center of attention in the photo. Fortunately, the photographer is not at the mercy of the AF points. You can allow the camera to choose the best one, or you can select the one that you want. In the latter case, the usual choice would be the central AF point, because its cross sensors can handle the greatest variety of subjects. Also, it has become almost second nature to aim

With automatic focusing point selection the camera will automatically focus on the closest object—not necessarily what you might have had in mind. If you want to focus on the dock, be sure to select the focusing point manually and lock focus.

▷ To photograph such a busy scene, it is best to switch to manual focus (using the AF/M switch on the lens). The photographer should choose the elements to emphasize and set focus accordingly. The autofocus sensors are programmed to focus on the closest object in the scene, which does not always create the most interesting photograph.

right at the subject to focus (and then lock in that distance setting, if necessary). With vertical-format portraits, however, it makes sense to select the AF point closest to the subject's eyes.

Of course, the Elan IIE offers another option: Eye Controlled Focus. Once the camera has been calibrated to your vision, a mere glance at any AF point immediately activates it. This procedure soon becomes instinctive, offering complete creative freedom and great shooting speed. Much more on Eye Controlled Focus will follow.

For now, let's see how to select the desired AF point, using the focusing point selector and the Main Dial:

1. Turn the Command Dial to one of the Creative Zone modes, such as Program AE, Shutter-Priority AE, Aperture-Priority AE, Manual exposure, or Depth-of-Field AE.

2. Press the focusing point selector. The active field (or fields) now blinks red in the viewfinder. Generally, when making these settings, you will be looking at the LCD monitor, where the active field (or fields) blinks as well.

3. Turn the Main Dial until any or all of the three points appear. On the Elan IIE, you can also elect to use Eye Controlled Focus and choose one of the three pre-set calibration settings. With Eye Controlled Focus, the calibration number, three focusing point rectangle symbols, and the eye symbol will blink on the LCD.

4. Touch the shutter release to confirm your selection: single-field, three-field auto-select, or Eye Controlled Focus (IIE only). If six seconds go by before you touch the release, the currently displayed setting will be retained. (In the Full Auto operating mode, only three-field AF is available.)

◁ **The Elan II/IIE's multi-point autofocus system is ideal for photographing people. The top focusing point was manually selected to focus on the little boy's eyes. This was photographed in Program mode, using the camera's built-in flash for fill.**

Eye Controlled Focus

The Elan IIE has an advanced feature the Elan II doesn't—Eye Controlled Focus. The Elan IIE has sensors in its viewfinder that can detect which way your eye is looking and activate the corresponding AF point. To work properly, the system first must be calibrated to your eye. This simple process takes only a few seconds.

Three calibration storage settings are available. This means that up to three different people can use the Eye Controlled Focus mechanism. When calibrating, it is important that the camera "learns" about your eye the way it will be when you are photographing; so if you shoot with glasses or contact lenses, perform the calibration while wearing them. And make sure your glasses are seated properly, not just perched on the end of your nose.

Calibration can be done in bright sunlight or in backlight with the rubber eye cup attached to the eyepiece. Place the camera firmly against your forehead, keeping your eye directly in front of the eyepiece. There should not be any objects, such as stray hair, between the eye and the eyepiece. Look at the optical axis (center) of the viewfinder so you can see the entire viewfinder image. Be sure to hold the camera steady.

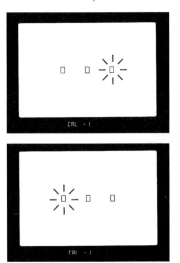

When Eye Controlled Focus is being calibrated, the right focusing point blinks first, then the left. Press the shutter release lightly with each calibration.

1. Turn the Command Dial to CAL. "CAL-1" (or 2 or 3) appears on the LCD and in the viewfinder. As long as the calibration number blinks, that setting location is free. (You can free up a calibration setting location by pressing the AE lock button and

focusing point selector at the same time, which deletes the previously stored setting.)

2. Select the desired, available calibration setting location (1, 2, or 3) using the Main Dial.

3. Holding the camera as described above, lightly press the shutter release and look at the right-most AF field (which is blinking) for about 1 to 2 seconds. The field then goes dark and the beeper sounds (if activated).

4. Repeat the operation with the left-most field (which is now blinking). The display "End-1" (or 2 or 3) will appear afterward in the viewfinder and LCD panel.

This sets up the camera for horizontal shots. Now a separate calibration has to be performed for vertical use:

1. Hold the camera in a vertical position at your eye. (It does not matter if the handgrip is up or down.)

2. Lightly press the shutter release. The upper field will start blinking in red.

3. Look at this field for 1 to 2 seconds until it goes out and a beep sounds (if activated).

4. Repeat the process with the lower AF field. Afterward, "End-1" (or 2 or 3) will appear in the viewfinder and LCD panel.

When using the Eye Controlled Focus system, the same camera handling instructions given earlier still apply. Another important tip: *Never let another person use the Elan IIE at a calibration setting created for your vision.* He or she is unlikely to get optimum results, because each person's eyesight is different. More important (to you, at least), the calibration itself will be compromised.

As you use the Elan IIE with the Eye Controlled Focus system, it keeps "learning" more

Repeat the procedure to calibrate Eye Controlled Focus for vertical shooting.

about your eye, allowing a higher degree of focusing accuracy under different lighting conditions. But if you subject the system to an unfamiliar eye, it will try to incorporate these seemingly "abnormal" readings into its established data base. So if someone else is to use your Elan IIE, either turn the Eye Controlled system off, or have the user calibrate it for his or her own vision using another calibration setting location.

The Eye Controlled Focus setting—like any other AF function—is maintained when the camera is turned off. Even changing the battery does not affect it.

Eye Controlled Depth-of-Field Preview

The *pièce de résistance* of the Eye Controlled Focus system is its ability to stop down the lens for depth-of-field preview (Elan IIE only). Many current SLRs have trouble performing this vital function by conventional means, usually restricting it to a few exposure modes. How remarkable to be able to do it at a glance!

First, the basics. Depth of field depends on the lens' focal length and the chosen aperture. But the image in the viewfinder always shows the maximum aperture, thus minimizing apparent depth of field. This makes the plane of focus more visible, while keeping the viewfinder image bright. But it also may create a viewfinder image quite different from what will appear on the film.

With relatively good light and a fast lens, you tend to work at apertures considerably smaller than the maximum. That's why the background that was so nicely blurred in the viewfinder appears annoyingly in focus on the final print—competing for attention with your main subject. So it is a fine idea to stop down the lens to the working aperture and preview the range of sharpness. Naturally, the viewfinder image becomes darker as you are looking through a smaller opening. Yet everything will be clearer, including possible reflections, light sources, and the telephone pole growing out of your subject's head!

The more convenient it is to preview depth of field, the more likely you are to actually do it. And that's where Eye Controlled Focus really shines. The procedure is simple. Focus on the subject and keep your finger on the shutter release. Within six seconds, look at the small box in the top left corner of the viewfinder. This will signal the lens

diaphragm to close down automatically to the working aperture. You can lift your finger off the shutter release to re-open the aperture, or press down on it all the way to make the exposure.

For Eye Controlled depth-of-field preview to function, the focusing system must be set to One-Shot AF, and the Command Dial turned to a Creative Zone mode. In the Program, Aperture-Priority, Shutter-Priority, and Manual modes, you may want to place your middle finger on the shutter release and use your index finger to turn the Main Dial to select different values. Changing the aperture alters the depth of field, an effect that is plainly visible in the viewfinder. Of course, you should also keep an eye (so to speak) on the viewfinder display, making sure the resulting exposure time will not be too long to hand-hold.

Owners of the Elan II need not despair. They (as well as IIE users) can control image sharpness precisely with the Depth-of-Field AE mode, which will be discussed later.

Autofocus Modes

The Elan II/IIE can handle widely different situations using its three AF modes, selected with the large AF mode dial on the top right-hand side of the camera.

One-Shot AF

This AF mode is sometimes referred to as "focus priority," which means just what it says—that focus has the right of way. Until focusing is complete, the shutter button will not release. This prevents out-of-focus images, and also allows you to lock in a particular focusing distance for as long as you hold the shutter release. You can therefore change the composition as desired, without altering the plane of focus. Exposure information is stored at the same time as the focus data, on the reasonable theory that you want the main subject to be both sharp and well exposed. One-Shot AF is so generally useful, you may well consider it to be your normal focusing mode, particularly for stationary subjects.

AI Servo AF

In this mode, the shutter can fire even before the focusing operation is complete. Designed for moving subjects, AI Servo AF

One-Shot AF mode with focus priority is ideal for taking photos of quiet, unmoving subjects like this.

incorporates Predictive AF. This means that the AF sensor "locks" onto the main subject, determines its direction and speed, and calculates where the object will be at the moment of exposure.

Predictive AF even compensates for the unavoidable split-second that elapses between the time the shutter release is pressed and the moment of actual exposure, as the reflex mirror flips up and the aperture closes to its working value. It may seem minor, but with a long lens and shallow depth of field, this small delay might well carry the subject out of focus. The extrapolation (or prediction) makes sure the lens is focused where the subject will be located at the critical instant of exposure. Exposure is set precisely, just before the shutter fires.

Eye Controlled Focus (on the Elan IIE) also contributes to the functioning of the AI Servo mode. Just let your eye rest on the AF point toward which the subject is moving to give Predictive AF its best shot at focus tracking. AI Servo should be used with continuous film advance. Focus lock is not possible in this AF mode.

AI Focus mode offers the best of both worlds. The camera "assumes" it is in One-Shot AF until a focused upon, stationary object starts to move. It then switches automatically to AI Servo AF to maintain focus on a moving subject.

AI Focus AF

This most sophisticated mode is actually a combination of One-Shot AF and AI Servo operation. With stationary subjects, you have One-Shot operation, so the shutter can be released only after successful focusing. But if the object starts moving, the camera instantly switches to AI Servo, complete with the focus-tracking abilities of Predictive AF. But the latter function is operative only for a subject that has first been focused by the central AF point.

One disadvantage of this mode is that it doesn't allow focus lock, even with stationary subjects. When the AF system senses a change of distance between the subject and the central AF point, it refocuses, even if the change is caused by the photographer recomposing the scene. Nonetheless, AI Focus AF is an excellent melding of the two other modes, keeping the Elan II/IIE ready for both still and moving subjects.

When Autofocus Gives Up

Nothing in this world is perfect, not even the AF system of the Elan II/IIE. Although it works superbly most of the time, there are a few limitations that you must understand and compensate for.

Basically, the AF system scrutinizes and compares image areas. When contrast is maximized, proper focus has been achieved. That's why the system cannot function properly in the following situations:

1. When a surface has no structure or contrast.
 Autofocusing on a wall or a blue sky is generally not possible because there are no differences between image areas for the system to compare. (Exception: Over short distances, the AF assist beam can facilitate AF by projecting a pattern onto a surface.)
2. When strong reflections are present.
 These "blind" the system, just as they might dazzle our eyesight. This category includes reflections on water, metal, or highly polished surfaces.
3. When the main subject is obscured by overlapping information in the foreground, such as a canopy of leaves or cage bars.
 This problem is most pronounced if you use all three AF points, because they are designed to focus on the closest subject, which is probably not the one you want. (This case is different from the first two because AF has been achieved, albeit in the wrong place.)

Fortunately, the viewfinder display always warns you if AF has not been accomplished. And in the One-Shot AF mode, the shutter release locks. A simple remedy is to find another object at the same distance and lock focus onto it. Then recompose and take your picture.

If all else fails, bite the bullet and slide the focus mode switch on the lens to manual (M). You then focus by turning the focusing ring while looking at the viewfinder image, just like in the good old days. Imagine, large-format photographers still have to use this outdated method!

TTL Exposure Metering

Sharpness is not everything in photography; correct exposure is just as important. The latter presents a continual challenge to the camera, because lighting conditions are always changing, and each subject has its own contrast characteristics. Whatever the situation, the Elan II/IIE has to determine the amount of light that will produce the optimum exposure on the film being used.

Although for many years SLRs have not shown any outward, visible signs of incorporating complex metering systems, internally the metering systems keep getting more advanced. The Elan II/IIE's silicon photocell (SPC), like most, works behind the scenes. Located the same distance from the lens as the film plane, the SPC measures the incoming light. This internal metering method is generally known by the abbreviation "TTL," for Through-the-Lens.

The advantages of TTL metering are overwhelming. It allows the cell to measure the amount of light passing through the lens on its way to the film. This automatically compensates for most filters, lens extensions (such as in macro photography), teleconverters, or any other kind of attachment, eliminating the need for tedious calculations.

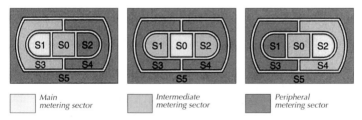

The Elan II/IIE's silicon photocell is divided into six sectors. The left-hand diagram shows how the sectors are weighted when metering is linked to the left focusing point. The center diagram shows how the sectors are weighted when metering is linked to the central focusing point, and the diagram at right shows how the sectors are weighted when metering is linked to the right focusing point.

More recently, TTL meters have become so sophisticated that they can make separate readings of several areas of the image.

These readings are automatically compared and analyzed, enabling the system to recognize backlight or high-contrast situations, and compensate for them as best it can. Called multi-zone or evaluative metering, this method is the most generally useful of the Elan II/IIE's three metering modes.

Selecting a metering mode is done with the metering mode dial, with pictograms indicating evaluative, partial, and center-weighted average metering.

Six-Zone Evaluative Metering

The Elan II/IIE's metering cell is divided into six sections, each of which delivers an independent reading. Complex equations (called algorithms) in the camera's computer are used to evaluate the data, and an exposure value is determined from the result. This detailed analysis results in more accurate and consistent exposures than were possible with previous metering methods. So six-zone

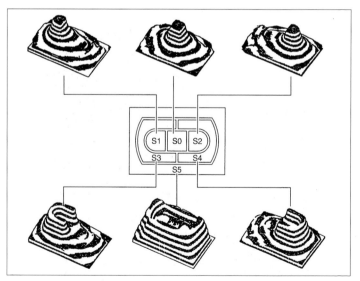

A representation of how the individual metering sectors are weighted within the picture frame.

evaluative metering should be regarded as the primary exposure mode, capable of yielding good results even in fast-changing light.

Again, even evaluative metering has its limits. If you run into problems, either select another metering mode, or (departing from common advice) use an exposure correction. Most authorities do not recommend the use of exposure compensation with evaluative metering because the metering algorithm already contains a substantial and unknown correction. But in practice, things look a little different.

At first, you have to let the multi-zone meter work on its own. When in doubt as to whether it will be able to handle a difficult situation, make one image using evaluative metering and a second picture with one of the other metering modes. Practical examples might include sun-dappled landscapes, other scenes with great contrast, or subjects shot in extremely high- or low-key light. Such experiences will show you when evaluative metering has reached its limits and by how much to correct the exposure. Despite all theoretical objections, this approach works very well.

Canon's AIM system automatically links focusing, exposure metering, and flash control.

AIM Carefully

Canon assumes that the main subject is located at the active AF point, whether in the center or at either outer point. So why not couple the focusing system to the multi-zone exposure meter? Canon's AIM (Advanced Integrated Multi-point control) system seamlessly integrates autofocus, exposure metering, and flash control. Evaluative exposure measurement (and flash metering) is thus weighted to the currently active AF point, while the surroundings are given less emphasis, as determined by the computer algorithm.

This system works quite well for portraiture, sports, and general candid photography. With complex stationary subjects—such as landscapes—the AF-controlled weighting can produce noticeable exposure differences (see the comparison photos on page 71). Results may vary with light or dark subjects, depending on their location in the image. You can use AE lock to set exposure for a particular area of the photo. With evaluative metering, the focusing point is also the active metering point. Center the point on the area you want to meter; press the AE lock button. Then recompose the photo.

Partial Metering

Partial metering is helpful in particularly difficult situations, when you need to control the exposure precisely. Only about 9.5% of the image area (around the central AF point) is measured.

Unlike evaluative metering, the partial metering mode lets you aim the metering area directly at the most important section of the image. The 9.5% area is somewhat larger than a true "spot" meter, making it less fussy and easier to use. Nonetheless, the exposure will be determined by the metered area, leading to potential disaster if you choose an overly bright or dark portion. Partial metering is therefore not recommended for beginners, who will definitely obtain better results with the evaluative system.

Experienced photographers often use partial metering with the AE lock function because the subject area used to determine exposure is seldom located right in the center of the frame. You aim the central AF point (partial metering area) at the chosen area, lock in the exposure, then recompose. If this area is your main subject as well, you may want to lock in the AF by pressing the shutter release down partway.

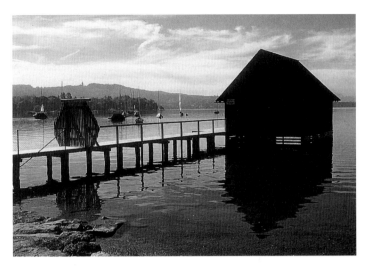

These shots taken within seconds of each other demonstrate the different effects that can be produced by the Elan II/IIE's AF and metering systems being coupled. When the Eye Controlled Focus is directed at the bright dock (using the central metering sector), a fairly well-balanced exposure results. However, by using the right focusing point aimed at the dark boathouse, overexposure results.

You can avoid the "lock-and-recompose" procedure by setting Custom Function 8, setting 1. This allows partial metering to be linked to any of the three AF points (selected by you), so that the active focusing point also becomes the metered area. For utmost convenience with the Elan IIE, the linked AF and metering point can be chosen by Eye Controlled Focus.

Center-Weighted Average Metering

For decades center-weighted average metering was the standard in SLR cameras. It measures the entire image field emphasizing the central area, with sensitivity gradually diminishing toward the edges.

Even today, with far more sophisticated methods available, center-weighted metering is still valued for its familiarity and predictability. There is no AE correction or interpretation as with evaluative metering, and no need to choose the right area, as when using partial metering. If you understand how center-weighted light meters work, you can accurately forecast the results and select an appropriate correction when necessary.

 The metering system is biased toward the central sectors when center-weighted average metering is used.

So how does an exposure meter work? First, it is calibrated to 18% neutral gray, so the meter "assumes" that any surface it encounters is gray and reflects 18% of the light hitting it. As you can see, this is a pretty narrow definition of a very eclectic world.

Once in a while you may aim your camera at a brilliant winter scene in which everything is covered in white snow. All the meter knows is that there is an overabundance of light, so it stops down the aperture and selects a fast shutter speed *to reproduce the snowy scene as 18% neutral gray.* After all, that is what it was designed to do.

On another day, you may want to photograph a shadowy, tree-lined slope. The meter reacts to this dark scene by choosing a wide

Center-weighted average metering is ideal for silhouettes. Careful plus (+) exposure corrections allow you to gain detail in the shadows under favorable conditions.

aperture and a relatively long exposure time. This renders your mysterious forest (you guessed it) a dull, 18% middle gray.

These extremes should make the basic principles clear. Any subject that is not medium gray (or a color with similar reflectance) may require exposure compensation to be reproduced properly. Therefore a close-up of a white cat needs extra exposure to make it lighter with center-weighted average metering, and a black cat requires less than the metered setting to make it darker. If you blindly follow the meter, both cats will be rendered as 18% medium gray.

Another common example is a spotlit performer against a dark background. The large, dim area tempts a center-weighted average exposure meter to overexpose, to lighten the darkness. If you follow the meter's recommendation, your real subject, the person in the spot, will become totally washed out. In this case, an adjustment toward underexposure is required.

All of this exposure finesse works best with slide film. When shooting negative (print) film, your corrections may come to naught. The printer in the lab may interpret your (properly) dense negative of a snow scene as being overexposed and add extra printing time. This results in the same effect you wanted to avoid, namely gray snow. If such problems occur, discuss them with the lab manager so that the prints can be redone as you desire.

In one situation, the "wrong" exposure produced by center-weighted average metering can be an advantage. If you want to shoot silhouettes or dramatic sunsets, the resulting underexposure is often just right. In fact, you can obtain exactly what you want without any corrections. Evaluative metering, on the other hand, does not guarantee this result, as it strives mightily to "ignore" extremely bright image areas. It therefore does not reduce exposure drastically enough, and the sunset becomes very bland.

Next Stop—The Creative Zone

Now we come to the Creative Zone, the group of exposure functions located counterclockwise from the L (lock) setting on the Command Dial. Even here there is a good deal of automation—particularly at the Program AE (P) setting. (This mode is not the same as the Full Auto program or any of the PIC modes.) The remaining functions are either semi-automated: Aperture-Priority (Av) and Shutter-Priority (Tv); or fully manual: Manual (M). The final setting, Depth-of-Field AE (DEP) is a different sort of mode, and it will be discussed separately.

The Creative Zone encourages user participation, and thus satisfies advanced photographers who have already learned how to optimize their results. In this regard, the options offered by the Elan II/IIE are very complete.

Program AE (P)

This mode is conceptually similar to Full Auto, but far more flexible. The aperture and shutter speed are both chosen automatically, according to a formula that integrates light level, film speed, focal length, and maximum aperture of the current lens. Unlike Full Auto, it offers the option of shifting the program (which we will discuss shortly), as well as using exposure compensation and totally controlling the flash.

After you set the Command Dial to P, touch the shutter release and the Elan II/IIE will focus and select an exposure setting. The working aperture and shutter speed are displayed in the viewfinder. As long as these values are not blinking, the camera is ready to take a well-exposed shot. You should pay attention to the shutter speed and switch to a tripod (or use flash) if it is too slow for handholding.

In extremely low light, the longest exposure time (30") and the lens' largest aperture (for example, 2.8) blink on the LCD to warn of potential underexposure. With relatively close subjects, the flash may help you out. Otherwise, switch to faster film or add more ambient light if possible.

On the other hand, in brilliant sunlight the shortest exposure time (4000) and the smallest aperture (for example, 22) may blink to warn of overexposure. A neutral density (ND) filter can help here, or you can switch to slower film.

Program AE is ideal if you are not quite comfortable juggling exposure times and apertures, particularly when things are happening thick and fast. It lets you concentrate on composition, yet still control image rendition. For example, you are free to choose single-frame or continuous film advance; One-Shot, AI Focus, or AI Servo AF; any one or all three AF points; Eye Controlled Focus (Elan IIE only); any metering pattern; fill flash; and the famous Program Shift. You might think of Program AE as a custom-made suit, whereas Full Auto is a standardized item, right off the rack.

Program Shift

Lens aperture and shutter speed interact to create each exposure. Consider the analogy of a water faucet filling up a bathtub: the aperture controls the *amount* of flow, while the shutter speed determines the length of *time* the spigot is open. The tub fills up with the same amount of water, whether it flows rapidly or gradually.

In a similar way, each film requires a certain amount of light to create a proper exposure. You can accomplish this with high shutter speeds and wide apertures or with slower speeds and smaller apertures. A change of one step in either value can be offset by an equivalent change in the other value, without altering the total exposure.

So there really is no "standard" exposure. For each aperture-shutter speed pair selected by the Program AE mode, there are several others that would produce the same exposure density on the negative or slide. You simply add to one value and subtract from the other in equal increments.

As an example, assume the Elan II/IIE has selected an exposure of 1/125 second and f/5.6. This is probably a good choice, as it provides a shutter speed fast enough for hand-holding and reasonable depth of field. But you may be dealing with a fast-moving subject whose motion can be arrested only with a faster shutter speed. Without changing the total exposure, you can increase the

Program AE mode allows you to take a picture in a split second if you come across an unexpected subject.

camera's ability to stop action by selecting one of the following combinations (if lens speed allows):

1/250	second	and	f/4
1/500	second	and	f/2.8
1/1000	second	and	f/2
1/2000	second	and	f/1.4

Alternately, a still life or landscape may cry out for more depth of field. More extensive depth of field can be obtained progressively with one of these combinations:

1/60	second	and	f/8
1/30	second	and	f/11
1/15	second	and	f/16
1/8	second	and	f/22

If you examine the values carefully, it becomes clear that creative freedom has a price. Moving in the direction of stopping action increasingly, you are limited by the wide aperture required, which may be unavailable on a typical zoom lens. Your only choice is to use a faster film, which, to extend our analogy, is equivalent to bathing in a smaller tub. It may not be comfortable!

Using smaller apertures and slower speeds will certainly increase depth of field, but there are limitations here as well. For one thing, fast-moving subjects will be rendered as a blur (which is fine if that's your goal). For another, the camera-shake boundary approaches rapidly, making handheld photography questionable. The only recourse is to support the camera firmly or use a tripod if one is available.

Putting these limitations aside, the Program Shift feature lets you assess the alternatives in a split second. Simply turn the Main Dial after you press the shutter release partway (to autofocus). The aperture-shutter speed combination can be shifted by 1/2 stops in either direction without affecting the exposure itself. The Program AE mode thus combines the speed of fully automatic operation with the creative option of modifying the exposure settings.

There is, however, one condition: You must turn the Main Dial while the exposure system is active, within 4 seconds after you lift your finger from the shutter release. Each turn of the dial keeps

the metering system active for an additional 4 seconds. After that, the camera reverts to the standard Program AE mode settings. If you maintain light pressure on the shutter release, the "shifted" exposure combination is maintained.

Taking a picture erases the Program Shift's memory. You can then use the standard settings, or enter a new pair of shifted settings. Program shifting is not possible with flash.

Shutter-Priority AE (Tv)

This "Tv" has nothing to do with your television set. It is an abbreviation for "Time Value," referring to the fact that the photographer determines the shutter speed (in 1/2-stop increments). The Elan II/IIE automatically selects an aperture (from a stepless scale) appropriate for the lighting conditions and the film speed.

As you know, high shutter speeds tend to freeze subject movement and neutralize camera shake as well. (The camera, after all, does not care if it is the subject or your hand that is moving.) Conversely, subject and camera movements become quite noticeable during long exposures. At times, the latter effect may be desirable, to create images of flowing water or a bird floating in the sky.

The amount of blur is, however, hard to determine. It depends on the speed and direction of the subject and the reproduction size of the final image. An object traveling at right angles to the camera is the most difficult to capture sharply, particularly in large prints or projected slides. Movement along the lens axis, directly toward or away from the camera, is much easier to freeze.

When you touch the shutter release, the aperture and shutter speed values are displayed in the viewfinder and on the LCD. Tv mode allows you 4 seconds to turn the Main Dial and change the shutter speed; the aperture is simultaneously adjusted by the camera.

In Shutter-Priority mode, it is wise to keep a close watch on the aperture display. If the lens' largest aperture (smallest f/number, such as f/2.8) begins to blink, underexposure is imminent at the preselected shutter speed. To avoid this, select a slower speed that makes the display stop blinking.

If the smallest available aperture (largest f/number, such as f/22) is blinking, the selected shutter speed is too long and will cause overexposure. In this case, shift to a faster speed, so that the

Shutter-Priority AE mode allows you to choose the shutter speed most appropriate to the subject's movement. A relatively fast shutter speed freezes motion, and a slower speed can record a bit of motion blur to emphasize the action.

aperture display stops blinking. This may reduce your depth of field, but it will also yield sharp, properly exposed images. In extremely bright light, when the aperture symbol keeps blinking even at 1/4000 second, you need slower film or a neutral density filter.

The Elan II/IIE offers a wide choice of shutter speeds, from 1/4000 second to a full 30 seconds. These standard values are divided into 1/2-stop increments, shown without a seconds symbol (") up to 1/2 second and with a seconds symbol for shutter speeds longer than that. For example, 4000 stands for 1/4000 second; 0"7 designates 0.7 second (the setting halfway between 1/2 and one second); and 1.5" means 1-1/2 seconds.

Aperture-Priority AE mode makes it easy for you to control the depth of field and tailor it to your particular situation (lens focal length, lighting conditions, etc.).

Aperture-Priority AE (Av)

Aperture-Priority AE (Av) mode is the opposite of Shutter-Priority AE. In Av, you choose an aperture (in 1/2-stop increments) and the camera automatically picks the appropriate shutter speed from a stepless scale. (If you were wondering, Av stands for "Aperture Value.") The Elan II/IIE is capable of selecting aperture values from f/1.0 to f/91; the lens mounted on the camera determines what section of this range is available.

Because the aperture determines depth of field, Av mode lets you control the zone of sharpness in the image. For a portrait, you may want to open the diaphragm all the way (to the largest aperture, with the smallest f/number), so the background goes out of focus. You will automatically have the pleasure of dealing with a short exposure time, preventing motion blur.

Landscapes generally require more depth of field, obtained by closing the diaphragm to a smaller aperture (larger f/number). If you want to handhold the camera, make sure to choose an aperture that allows a reasonably fast shutter speed.

In copy work—to name a third classic Av application—you usually stop down to about f/11 or f/16 to obtain corner-to-corner sharpness with a flat subject. (Depth of field is obviously not a consideration.) The resulting exposures are often quite long, but this doesn't matter, because the camera is mounted on a tripod or copy stand.

Aperture-Priority is the most versatile of the AE modes, easily adaptable to many unusual situations. Even if you turn the Elan II/IIE into a pinhole camera, using a piece of metal with a hole in it as a "lens," Av mode will still work. No fancy electronic or mechanical coupling is required to obtain good exposure.

The only caveat for Av photography is that you have to monitor the camera-chosen shutter speed. In bright light, the potential problem is overexposure, signaled by a blinking "4000" in the finder. To remedy this, stop down the aperture by turning the Main Dial until the blinking ceases. If there is still too much light, even at the smallest aperture (such as f/22), the use of a neutral density filter or slower film is required.

A more common concern in Aperture-Priority mode is the need to avoid shutter speeds that are too slow for handholding. You are the best judge of your own steadiness, although using the "reciprocal of the focal length" rule is a good guide. Again, you alter the aperture (and therefore the shutter speed) by turning the Main Dial. When the ambient light is insufficient, even with the lens wide open, you have three choices: 1) use flash, with relatively close subjects; 2) mount the camera on a tripod; or 3) switch to faster film. If the longest exposure time (30") blinks to warn you of underexposure at full aperture, only the first and third options are viable.

Manual Exposure (M)

Despite all automation, demanding photographers sometimes like to control apertures and shutter speeds manually. The Manual mode allows you to create unique effects and achieve specific photographic goals simply by turning the Command Dial to "M."

Since there are two variables to adjust, we clearly need two control dials. The Main Dial lets you adjust the shutter speed in 1/2-stop increments. To set the aperture in 1/2 stops, use your right thumb to turn the Quick Control Dial. This device has to be activated first by moving the switch above it to "1."

Even in Manual mode, exposure guidance is available from the Elan II/IIE's metering system. A handy scale, graduated in 1/2-stop increments from -2 to +2 EV, appears in the viewfinder and on the LCD panel. Under this scale is an indicator representing the current exposure level. You can easily adjust the aperture and/or shutter speed to move the indicator to zero, which signifies proper exposure as determined by the camera. Each variable can be set in 1/2-EV increments, permitting fine control of the exposure values. If the indicator is blinking at either end of the scale, the chosen exposure is over or under by more than 2 stops.

As fast as Manual mode works with the Elan II/IIE, the AE modes are even faster. They are even more precise as well, setting one or both variables on a stepless scale. So there is no advantage in switching to M unless you really need to avoid automation. Some examples might include fireworks photography, time exposures beyond 30 seconds, and multiple exposures on a single frame. As you can see, the Manual mode is generally recommended for very specific situations—but for those, it is indispensable.

Time Exposure (buLb)

Exposures of up to 30 seconds can be controlled automatically by the Elan II/IIE. For normal applications, this is more than adequate. But if you do want to exceed the time limit, it is easily done.

In the Manual mode, turn the Main Dial past 30" until the word "buLb" appears on the display. At this setting, pressing the shutter release starts the exposure, and releasing the button ends it. You can keep the shutter open for as long as you wish, assuming the camera's battery remains operative. If the battery poops out in mid-exposure, the shutter closes.

The Elan II/IIE obviously has to be mounted on a solid tripod during time exposures. Use of Canon's RS-60ES remote switch is also recommended, unless you have a very strong finger. Even if you do, the shot could be ruined by unavoidable movements of your hand.

The Bulb setting takes over where the automatically controlled shutter speed range leaves off. It is particularly useful when taking night shots.

To set the aperture, turn the Quick Control Dial until the desired value is displayed. Now you can execute your photographic feat, providing that you have figured out the proper exposure. The "buLb" signal will blink on the LCD for the duration of the exposure.

Naturally, the light meter doesn't work in Bulb, because no shutter speed value has been stipulated. As a rough guide, you can take an exposure reading at 30 seconds, then adjust the aperture for whatever time you actually choose (with an addition for reciprocity failure). With subjects such as fireworks, however, experience is the best guide—as is described below.

Photographing Fireworks

Nothing is easier than capturing this spectacular subject. Place your camera on a tripod, with a lens (or zoom focal length) of 28mm to 35mm. But don't think that you need a speedy lens or fast film. Quite the contrary—fireworks are so bright that you have

A fireworks display is an exciting photo opportunity. Use the Bulb setting to keep the shutter open long enough to expose a cluster of fireworks on each frame of film.

to stop down considerably, even with medium-speed film! Proper exposure results in maximum color saturation, according to this simple rule of thumb: with ISO 100 film use f/11.

You can adjust this equation for other films, selecting f/8 with ISO 50 film, f/16 with ISO 200, etc. For high-speed film such as ISO 400, you have to stop way down to f/22 to prevent overexposure, which would wash out the colors.

Fireworks are best photographed with the Elan II/IIE in the Manual mode at the "buLb" setting. Select the aperture with the Quick Control Dial, according to the above rule. When things get going,

open the shutter and *keep it open* until several interesting fireworks have exploded in the field of view. Only then release the button so that the shutter closes.

The length of time you keep the shutter open determines the visual effect of the image. No two fireworks are alike, so while the shutter is open, you have to imagine how the picture will look. You can try capturing a single burst or a whole series. Just don't be stingy with film. Even if you take many shots, each one will be different. You won't love them all, but a few will be terrific.

Depth of Field

Depth of field is another term that crops up in photography. Depth of field is best defined as the zone of acceptable focus, which extends beyond and in front of the point of focus. It can be thought of as the distance within a scene that appears sharp in a photograph, and it can vary greatly. It can be extensive, encompassing a great distance, or it may be only a few inches, as in macro photography. Understanding how to control and utilize depth of field will take the Elan II/IIE owner from snapshooting into the realm of creative photography.

Factors Affecting Depth of Field

An optical system can show only a single, flat plane in critically sharp focus. Therefore, in any photo, only subjects at the focused distance are actually razor sharp. However, depth of field can be controlled by the photographer to produce a zone of acceptable sharpness behind and in front of the point of focus. The principles governing depth of field can be summarized in four basic rules of thumb.

As aperture size decreases, depth of field increases: To think of this in terms of f/number, depth of field is directly proportional to the f/number. Doubling the f/number doubles the depth of field.

At a wide aperture of f/2.8, for example, the zone of apparent sharpness will have considerably less depth than at f/16. Only the primary subject will appear razor sharp, and its surroundings will be blurred to some extent. Conversely, the smaller the aperture, the greater the depth of field. At f/32, objects in both the foreground and background will be rendered acceptably sharp.

The depth of field is determined to a great extent by the diameter of the aperture. Whereas a relatively short depth of field is produced at f/4, a far greater depth of field is achieved at f/16 (when shooting the same subject under the same conditions).

Longer focal length lenses produce shallower depth of field: At the same aperture and distance from the subject, a 200mm lens will produce shallower depth of field than a 35mm lens. To confirm this point, take a picture of a person 8 feet (2.4 m) away with each lens set at f/5.6.

With the 200mm focal length, only the subject will be in precise focus in your picture; the distant background will be blurred. With the 35mm lens, much of the surroundings will be acceptably sharp as well. Your creative intentions will determine the right focal length. Telephotos are most useful when you want the viewer's attention riveted to the center of interest without having competing elements rendered sharply.

Note: There is one exception to this rule, which occurs in extreme close-up (macro) photography. The focal length no longer affects the depth of field in the macro range. Whether you use a 60mm Micro or a 200mm lens, depth of field is the same at high magnification.

The closer the subject, the narrower the depth of field: Depth of field increases dramatically as camera-to-subject distance

increases. With any lens, focus on a tree 30 feet (9.1 m) away and others in the frame will be acceptably sharp as well. Some of the trees closer to the camera and others behind the focused point will fall within the depth of field. Now set focus on a tree only 5 feet (1.5 m) away. Only this single tree will be rendered sharp in the final picture.

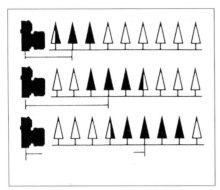

In addition to the aperture, the camera-to-subject distance also determines depth of field: the shorter the subject's distance from the camera, the shallower the depth of field.

Note: In both cases, the actual range of acceptable sharpness will vary based on the factors mentioned in the first two concepts.

Depth of field generally extends one-third in front of the point of focus and two-thirds behind it: Maximize the depth of field by focusing one-third of the way into a scene.

Note: Again, this factor is true with all but extreme magnification (as in macro photography) with a micro lens. Depth of field is roughly equal on both sides of the focused point in high-magnification work.

Varying Depth of Field
The effects of depth of field on the image are considerable. Manipulating this factor by using the aperture and focal length is one of the most useful creative tools the photographer has. Imagine a portrait with a busy background—the trees, weeds, poles, and cars all appear quite sharp. Extensive depth of field is achieved in one of three ways: with a small aperture (like f/16), a wide-angle lens,

or by shooting a great distance away from the subject (or some combination of these three factors).

Or, if you prefer a cleaner look with soft blurring, which would eliminate the obvious clutter, switch to a longer lens, move in closer, and open the aperture (to f/4, for instance). Shallow depth of field will de-emphasize the secondary elements in the frame.

In an environmental portrait, however, you may decide to maximize depth of field. In this case, the blacksmith and the tools in his workshop will all be reproduced in sharp focus. A 28mm lens at f/22 will create an effect that could never be matched by a telephoto lens with its shallower depth of field and narrower angle of view.

Or, consider a landscape that includes bushes in the foreground and a river in the mid-ground flowing from distant peaks rising majestically into the sky. Apply the first three rules mentioned above (increase the aperture, use a long focal length lens, and stand close to the main subject), and you will minimize the depth of field. Only the subject you focused on will appear sharp in the final picture.

If that's not the intended effect, the solution is easy. Switch to a wide-angle lens (perhaps 28mm) and stop down to a smaller aperture (perhaps f/16). Set focus for the rocks one-third of the way into the scene. Now, the depth of field will be far more extensive, keeping the focus over the entire scene acceptably sharp to fully appreciate its beauty.

Depth-of-Field AE (DEP)

We have already discussed how depth of field can be assessed in the Elan IIE's viewfinder, using the Eye Controlled Focus feature. (Users of the Elan II can set Custom Function C04, setting 2 for manual depth-of-field preview, as will be explained later.) Canon offers another convenient option, which allows you to define precisely the required zone of sharpness. This feature is called Depth-of-Field AE.

In Depth-of-Field AE mode, you simply have to tell the Elan II/IIE the locations of the closest and farthest subjects you would like to have in focus. Any one of the AF points can be used to define these distance settings; in the three-point AF mode, only

the center point is active. In the following explanation, we assume that Eye Controlled Focus is not activated.

1. Make sure the lens' focus mode switch is in the AF position.
2. Turn the Command Dial to DEP.
3. Aim the active AF point at the near subject and lightly touch the shutter release. "dEP 1" will appear in the viewfinder and on the LCD.
4. Aim the active AF point at the distant subject and again touch the shutter release. "dEP 2" will appear in the viewfinder and on the LCD. (You can define the far subject first if you prefer.)
5. Touch the shutter release a third time and hold it partway in. The viewfinder and LCD displays will show the required aperture-shutter speed combination to satisfy your depth-of-field needs.
6. Check to see if you can safely hand-hold the camera at the resulting shutter speed. If yes, go ahead and shoot.

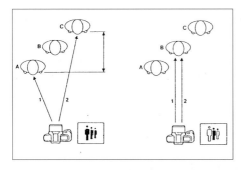

Depth-of-Field AE mode allows you to control the depth of field precisely. It can be used not only to produce great depth of field, but also to create a single plane of focus—simply place the near and far focusing points on top of each other.

Naturally, the smaller the aperture required to achieve the desired depth of field, the longer the corresponding shutter speed. If it's below the 1/focal length threshold, you have four choices:

1. Place the camera on a tripod.
2. Compromise on how sharp the nearest or farthest subject needs to be.
3. Increase the available depth of field by using a shorter focal length or by increasing the camera-to-subject distance.
4. Switch to faster film.

The first choice is probably the best, because the others will inevitably change the look of the image.

Another way of maximizing depth of field is to shoot in good light. You can't change the laws of optics, but you can certainly stack them in your favor. Just don't ask the Elan II/IIE to do the impossible. If the f/stop value blinks, the depth-of-field requirements cannot be met, even at the narrowest aperture.

On rare occasions, the longest shutter speed (30") and the widest aperture may both blink to signal that the scene is too dark for proper exposure. Even less frequently, the fastest shutter speed (4000) and the smallest aperture will both blink to warn that the scene is too bright. These problems can be remedied by the use of faster or slower film, respectively. A neutral density filter can also be employed to prevent overexposure.

Stored dEP values are canceled by changing the selected AF point or by moving the Command Dial off "DEP." One word of caution: Don't alter the focal length setting of a zoom lens after you make the near and far selections until after the picture has been taken. This would throw off the camera's depth-of-field calculations. Also note that flash does not work in the Depth-of-Field AE mode.

With the Elan IIE, you can use Eye Controlled Focus to define the near and far subjects. For maximum operating speed, just glance at any of the three AF points to choose the desired distance values.

Autoexposure Bracketing (AEB)

Some situations, including strong backlighting or other complex contrast relationships, cause problems for any autoexposure camera. To deal with them, the Elan II/IIE offers a powerful tool: autoexposure bracketing (AEB).

Even professionals bracket to ensure perfect results. You know the drill: one overexposed, one "correctly" exposed, and one underexposed image. To make this procedure work, you first must determine the appropriate amount of deviation from the "normal" exposure. The Elan II/IIE extends a range of possibilities from +2 EV to - 2 EV in 1/2-stop increments. Slide films require more careful modulation than do negative films, with their larger exposure

These photos were taken using autoexposure bracketing with a variance of 1 EV between each shot and using +1 EV exposure compensation. This has the effect of producing three shots with the following correction values: 1) no correction of the meter reading, 2) +1 EV, 3) +2 EV, instead of the usual underexposure, normal exposure, and overexposure sequence. This prevents unnecessary bracketing towards underexposure in a backlit situation such as this.

latitude. So for reference, let's assume an increment value of 0.5 EV for slide films and 1 EV for negatives.

To set AEB, press the function button and turn the Main Dial until the desired bracketing increment appears in the top right corner of the LCD. This value is also shown on an easily understood correction scale on the LCD and in the viewfinder.

If you use continuous film advance, the three bracketed pictures are taken in rapid succession while the shutter release is depressed. This is certainly more convenient than pushing the button three times in the single-frame mode. The Elan II/IIE takes the "normal" exposure first, then the underexposed shot, and finally the overexposed one.

Autoexposure bracketing remains active after the three exposures have been taken. To cancel it, you must reset the bracketing value to zero by pressing the function button and turning the Main Dial. AEB can also be used in conjunction with the self-timer.

AEB varies the shutter speed, the aperture, or both, depending on the exposure mode. To bracket properly, the Elan II/IIE needs sufficient "room" above and below the normal exposure setting. If the aperture or shutter speed required for under- or overexposure is beyond the available range, bracketing cannot be completed.

By combining AEB with exposure compensation (see the appropriate section), you create an even more versatile tool. You can shift the entire bracketing operation in the appropriate direction, so that, for example, backlighted scenes are bracketed completely on the plus side. If you were to combine an AEB interval of 0.5 EV with exposure compensation of +1 EV, the results would be:

First picture (normal) **= +1 EV**
Second picture (under) **= +0.5 EV**
Third picture (over) **= +1.5 EV**

This covers the overexposure range in small increments, without wasting film on a useless, underexposed image. The displays in the viewfinder and on the LCD convey the status of AEB and exposure compensation far more directly and clearly than the vague " +/- " shown by most other cameras.

Multiple Exposures (ME)

Not everyone wants to combine two, three, or more exposures on one piece of film. But if you have a desire to create such unique images, the Elan II/IIE makes the process relatively painless.

First, set the Command Dial to any Creative Zone mode. Then press the function button until two overlapping rectangles and the number "1" appear on the LCD panel. Now turn the Main Dial to select the desired number of exposures, from 2 to 9, as displayed on the LCD panel. Partial pressure on the shutter release saves the selection in memory.

Along with the selected ME number (which appears in place of the frame counter) and the ME symbol, the LCD shows relevant exposure data for the chosen operating mode. In theory, you can now fire one shot after another. In practice, this would result in overexposure, increasing with the number of shots taken. This is

only logical, as the Elan II/IIE exposes each image normally, without compensating for the other exposures on the same frame.

To achieve proper exposure, you need to dial in some "minus" (underexposure) compensation. A rough guide is -1 EV for two exposures, -1.5 EV for three, and -2 EV for four. This is only a starting point, because subject reflectance and background illumination determine the final result. In general, a dark background is

Photographing action, such as an exciting ride through the streets of St. Remy de Provence, demands continuous advance mode with Predictive autofocus. A 135mm soft-focus lens was used.

You will rarely be tempted to use the continuous advance setting in day-to-day, casual photography. But exciting situations can present themselves unexpectedly from time to time, and you will be happy that the Elan II/IIE's technology allows you to capture them.

desirable, allowing the individual shots to remain separate and clearly visible. It's best to learn for yourself by performing a few experiments.

The overlapping rectangles on the LCD will blink until all selected exposures have been taken. Then the ME function is canceled automatically and the film transports normally to the next frame. The frame counter treats all multiple exposures as one image.

To cancel the ME operation before it has started, just reset the number of multiple exposures to 1. And if you want to end the process after having made fewer images than expected, press the function button and turn the Main Dial until no number appears on the display. If you now press the shutter release (or just wait 6 seconds), the ME function is automatically canceled, and the film transports to the next frame.

Single-Frame and Continuous Film Advance

The Elan II/IIE offers two film advance modes, selected with the film advance mode lever located under the AF mode dial. Pointing the lever to the pictogram of a rectangle to set single-frame

advance. In this mode, the film transports one frame after each exposure and stops until you once again push the shutter release. For most subjects, this is fast enough.

When photographing action, however, you never know what the next instant will bring. To be prepared, set the lever to the overlapping rectangles for continuous advance. As long as you hold down the shutter release, pictures will be taken at speeds up to 2.5 fps (frames per second) until the film runs out.

We say "up to" 2.5 fps because naturally the exposure time and subject characteristics play a role. For one thing, the shutter speed has to be fast enough to allow a rapid framing rate, despite the time needed to move the mirror and adjust the lens diaphragm. And, depending on the subject and AF mode, the camera may also have to refocus before each shot. This takes up a few split seconds, slowing the framing rate and possibly making its rhythm irregular.

Predictive AF is an obvious complement to continuous film advance. If a subject is moving (the only kind really suited for continuous operation), the camera-to-subject distance is probably changing as well. Only Predictive AF (via AI Servo or AI Focus) gives the best odds for sharp images. This is doubly true for the Elan IIE, whose Eye Control mechanism makes the chances of success even higher.

Advanced Camera Functions

The various options and possibilities offered by the Elan II/IIE seem almost inexhaustible. This is particularly remarkable considering the moderate price, compact size, and light weight of this camera. Virtually all of these functions, even the self-timer, can contribute to your creative output.

Autoexposure Lock

To deal with tricky subjects, the Elan II/IIE lets you disconnect the normal link between autofocus and autoexposure. This is advisable if you want to base the exposure reading on a subject area different from the in-focus area.

In any Creative Zone mode, a press of the AE lock button holds the exposure reading for as long as you wish. When using the evaluative metering pattern, the active AF point "aims" the meter at the desired area; the partial and center-weighted metering patterns employ the central AF point for this purpose. There is, however, one exception. If partial metering has been reprogrammed using Custom Function C08, setting 1, the active AF point is used for exposure lock as well. Also, in the Eye Controlled Focus mode of the Elan IIE, if you press the AE lock button before touching the shutter release, exposure lock is linked to the central AF point.

The AE lock button allows you to lock an exposure reading on a selected area of the photograph.

Here's how autoexposure lock works:
1. Aim the active AF point where you want to lock exposure.
2. Press the shutter release partway to focus.

3. Press the AE lock button. If you do so within four seconds of focusing, a single, short touch on the AE lock button holds the exposure setting, with no need for continued pressure. But if you miss the four-second window, you have to keep pressing the AE lock button.
4. Aim the AF point at where you want to lock focus.
5. If you like the composition, press the shutter release to take the picture. If not, hold the shutter release in partway and swivel the camera to the final composition. Then press the shutter release in all the way to make the image.

When the shutter fires or the metering system shuts down, auto-exposure lock is automatically canceled.

Exposure Compensation

The need for exposure compensation has already been discussed in several places. Fortunately, the Elan II/IIE allows this process to be done quickly and easily, using the Quick Control Dial on the back of the camera. (You have to turn the dial on with the Quick Control Dial switch before it can be used. It's also a good idea to turn it off after dialing in the required amount of compensation.)

Turning the Quick Control Dial moves the indicator located underneath the exposure scale, as shown in the viewfinder and on the LCD. Note that if the metering system is off, the scale remains visible, but the indicator cannot move. In this case, lightly touch the shutter release to switch the meter on.

Setting exposure compensation using the Elan's Quick Control Dial just takes a second.

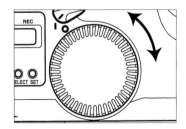

Exposure compensation can be made in either direction (plus or minus), by up to 2 EV, in 0.5 EV increments. Once chosen, the amount of exposure compensation remains in effect until it is

manually canceled, even if the camera has been turned off. A particularly nice feature is that the exposure scale remains visible in the viewfinder and on the LCD whenever the camera is on, making it difficult to forget that a correction is active. To cancel the compensation, turn the Quick Control Dial until the display indicates zero (0). Whatever its value, exposure compensation operates only in the Creative Zone.

Using the Self-Timer

The self-timer lets you smuggle yourself into the picture, by firing the shutter ten seconds after the shutter release is pressed. It works the usual way:

1. Place the camera on a tripod or other solid surface.
2. Press the self-timer button.
3. Within four minutes, while looking through the viewfinder, press the shutter release partway to activate autofocus and determine the exposure. (If you wait longer than four minutes, the self-timer function will be canceled.) Make sure that the active AF point is where you want it to be. If not, turn off the AF system and focus manually.
4. Press the shutter release all the way to start the ten-second countdown.
5. Quickly take your place in front of the camera and flash your best smile.

There are two good reasons to look through the viewfinder while pressing the shutter release. First, if you are focusing automatically, you must make sure that the active AF point is directed toward the proper detail. Second, to achieve an accurate exposure reading, the viewfinder eyepiece needs to be covered to prevent stray light from entering and affecting the reading.

If, for whatever reason, your eye will not be at the viewfinder when you press the shutter release, remove the rubber eye cup and replace it with the eyepiece cap on the neck strap. Also, under no circumstances should you stand in front of the camera when the countdown is started. Focus and exposure are set at that instant, and you don't want your midsection to be right in front of the lens.

The progress of the self-timer is indicated by the blinking AF assist beam and (if you choose) by the beeper as well—slowly for the first eight seconds, then quickly for the final two. The LCD shows the countdown, but you will most likely not be there to watch it.

In case you change your mind while the timer is running, simply press the self-timer button again, or turn the camera off to cancel the countdown. Selecting another exposure mode pauses the countdown but keeps the timer active, so the process will continue from where it left off when you next touch the shutter release.

To create more natural-looking photos using the self-timer, deny yourself the pleasure of looking directly at the Elan II/IIE. If there are several people in the shot, they could be talking to each other or doing something—almost anything but waiting for the birdie to pop out of the camera.

The self-timer is more versatile than you may think. When exposure settings are at the limit of what is acceptable for a handheld shot, the timer can help you achieve a degree of stability. Brace yourself against a table or railing, or crouch down, with your elbows on your knees, then fire using the self-timer. This gives you ten seconds to concentrate fully on holding the camera steady, avoiding any vibration caused by pressing the shutter release. Similarly, for occasional shooting on a tripod or copy stand, the self-timer can be used in place of the remote control.

Turning Off the Audible Signal

Audible signals can be helpful in confirming that a function is in use or warning of an impending error. On the other hand, they can be a distraction to the photographer and (especially) to the subject, who may wonder why the camera is beeping all the time. In such cases, it's a good idea to switch the beeper off.

Simply press the function button until the sound-wave symbol appears on the LCD. Now turn the Main Dial until a "0" (instead of the default "1") is displayed, and touch the shutter release to store this setting. The sound-wave symbol will disappear, and silence reigns.

Custom Functions

Cameras, like all consumer products, are designed to satisfy the greatest number of potential users. But experienced photographers have unique preferences, which are only gratified by a camera that can be "customized," such as the Elan II/IIE. No, you can't add red paint and flame decals, but Canon offers 11 truly useful Custom Functions, adjustable to fulfill your heart's desires. (To save space, these functions are identified on the LCD as "C" plus a number, rather than "CF.") The custom programming process is a breeze:

1. Turn the Command Dial to CF.
2. Use the Main Dial to select the desired custom program, displayed on the LCD as C01, C02, etc.
3. Press the Custom Function button, to change the 0 (factory default) setting shown on the LCD to 1 or 2.
4. Now turn the Command Dial to one of the Creative Zone modes. "CF" will appear on the LCD to signify that custom programming is in effect.
5. To restore a function to its factory default, reset the value to 0.

Function C01: Film Rewind Mode

The default (setting 0) setting for the rewind function of the Elan II/IIE is extraordinarily quiet—a true "whisper drive" that's great for all standard applications. In some cases, however, speed is more important than silence. That's why C01, setting 1 lets you program the camera to rewind quickly, accompanied by a slight increase in noise.

Function C02: Film Leader Position

When rewinding has been completed, the Elan II/IIE normally pulls the film leader all the way back into the cartridge (C02, setting 0). This saves you from the painful experience of loading the same film twice, producing 36 accidental double exposures.

But if the leader is fully rewound, it's difficult to reload a partially exposed roll. And for those who develop their own film, the lack of a leader means you have to pry the cartridge open, in the dark. To sidestep these hassles, use C02, setting 1 to reprogram the camera so the leader remains visible.

And if you leave the camera set to this setting, how can you then avoid accidentally reloading an exposed roll of film? Just discipline yourself to wind the leader into the cartridge manually, except with partially exposed rolls.

Function C03: Film Speed Setting

All of today's popular films are supplied in cartridges with DX codes. These black-and-silver patterns enable the film cartridge to communicate the film's ISO speed and length to the camera. After film is loaded into the Elan II/IIE, the ISO speed appears briefly on the LCD. To preclude disasters caused by a faulty or dirty cartridge, you should *always* check this display!

As mentioned earlier, you can manually override the automatically set DX film speed at any time. When the next DX-coded film is loaded, however, its automatic setting will supersede any manual ISO setting. With the Elan II/IIE, DX readings take precedence, creating a margin of safety for novice photographers.

Advanced amateurs, however, often choose to modify the official film speed to achieve maximum color saturation, optimum highlight detail, etc. For example, you might have an ISO 50 transparency film and an ISO 100 negative film, both of which are best exposed at ISO 64. It can become tedious to reenter this value with each new film. Custom Function C03, setting 1 offers the alternative of setting the film speed manually. With this setting, every time a new cartridge is loaded—even if it is DX coded—the previous (manual) setting is maintained.

Function C04: AE Lock, AF Lock, Depth-of-Field Preview

With this function in the zero (0, default) setting, touching the shutter release causes the Elan II/IIE to lock focus (and to lock exposure in the One-Shot AF and AI Focus AF modes); pressing the AE lock button locks exposure only, in all Creative Zone modes.

By moving C04 to setting 1, you change the arrangement. Now the AE lock button locks focus, and the shutter release locks exposure only.

In setting 2, the shutter release operates normally, but pressing the AE lock button stops down the lens. This is a great option with the Elan II, which does not offer Eye Controlled depth-of-field preview. Also in this setting, FE lock is disabled. (Note that C04 is the only Custom Function with three possible settings.)

When taking close-ups, using mirror lock-up and a tripod helps eliminate camera shake.

Function C05: Self-Timer/Mirror Lock-Up

This function changes the operation of the self-timer. With C05, setting 1, the self-timer causes the mirror to lock up two seconds before the shutter fires. With critical close-ups or copy work, this can lead to a distinct improvement in sharpness because any mirror-related vibration will have ceased by the time the exposure actually occurs.

Function C06: Flash Sync Timing

With C06, setting 1, the built-in flash and the Speedlite 380EX synchronize with the camera's second shutter curtain rather than with the first. Therefore the flash fires at the end, rather than at the beginning of longer exposures (which is the case in setting 0). See the *Flash* chapter for details.

Function C07: AF Assist Beam

When there is little or no light, the AF assist beam emitter sends

Pay close attention to the relationship between light and shadow. Isolate the subject, and get so close to it that it fills the frame. Side light is ideal; it produces shadows that give the appearance of depth and bring life to an image.

out dark red flashes. If these prove obtrusive, C07, setting 1 can be used to turn the beam off. The tradeoff is that autofocusing becomes more limited in low light.

Function C08: Partial Metering and FE Lock Linked to the Active AF Point
Partial metering and FE lock (in flash photography) are normally linked to the central AF point. With Function C08, setting 1, both can be linked to the active AF point (selected by the photographer).

Function C09: Flash Sync Setting for Aperture-Priority AE
The Aperture-Priority (Av) mode normally varies the flash sync speed according to the ambient light to retain detail in the background. Under certain lighting conditions, however, slow sync

speeds can produce streaks or ghost images. To avoid them, use C09, setting 1 to fix the sync speed at 1/125 second.

Function C10: AF Point Illumination
The Elan II/IIE's active AF points identify themselves by glowing red the instant that focus is achieved. In low light, this may be distracting, while under bright sunlight it is hardly visible. If the flashing bothers you, eliminate it completely by using C10, setting 1.

Function C11: Eye Controlled Depth-of-Field Preview (Elan IIE/ EOS 50E only)
If you don't like looking into the top left-hand corner of the viewfinder to activate depth-of-field preview, C11, setting 1 allows you to turn this feature off.

Canon Lenses and Filters

The most important capability of a fine SLR such as the Elan II/IIE is not apparent when you pick up the camera. Yes, it's wonderful to have advanced features, including multiple metering modes, quick autofocus, a bright viewfinder, ad infinitum. As you know by now, the Elan II/IIE includes all of these, and then some. But the best thing about a high-quality SLR is that it is the heart of a complete system of lenses and accessories. To draw a rather unfair (but somewhat true) comparison, if you start with a point-and-shoot camera, that's as far as you'll go. Start with an EOS Elan II/IIE, and your photography can expand as far as your imagination allows. This chapter offers an overview of the many choices in Canon optics. For more information, pick up the *Magic Lantern Guide to Canon Lenses* by George Lepp and Joe Dickerson.

EF Interchangeable Lenses

There are now about 50 models in the EOS EF (Electronic Focus) series of interchangeable lenses, with new items being introduced regularly. So there is hardly a lens desire that Canon cannot satisfy—creating the exquisite agony of choice. You should carefully consider the complement of lenses you already own before deciding what (if anything) to add.

Most importantly, your setup needs to be optimized for your type of photography and your budget. Try to have a minimum of focal-length overlap, adequate speed, manageable weight and size, and the fewest possible filter sizes. A bit of planning can save you a great deal of money and trouble in building a system of lenses and accessories.

A decided advantage of Canon's autofocus lenses is the built-in focusing motor. Most other manufacturers depend on a motor located in the camera housing. The action of these motors is transmitted to the lens via a shaft. Each EF lens, on the other hand, contains a motor precisely calibrated to its requirements for torque and focusing speed. After all, there are considerable differences in

The lens and camera transmit information via gold-plated electrical contacts. These contacts must be kept clean. After removing a lens from the camera, always set it down on its front element, and put caps on both the rear and front elements before storing it. Be sure to put a body cap on the camera when no lens is attached.

the amount of weight involved and the distance it has to be rotated. A wide-angle lens might require only a small focusing movement, while a long telephoto needs a herculean effort.

Data transmission between the Elan II/IIE and the lens occurs via gold-plated contacts on the camera and on the lens' bayonet mount. The lack of mechanical couplings guarantees precision and minimal wear over long, heavy use. There is no play and no energy wasted in mechanical power transfer. Electronic data transmission even makes it possible to close the aperture instantly for depth-of-field preview (with just a glance, using the Elan IIE's Eye Controlled Focus feature).

Canon continues to enhance its AF motor technology. The first step was the AFD (Arc Form Drive) motor, whose shape was adapted to the lens. Then came the compact USM (Ultrasonic) motor, which offers practically noiseless operation and impressive speed. A third version is the tiny, cylindrical MM (Micro Motor), giving solid performance at a modest cost. And for truly inexpensive lenses, there is the simple but effective belt-drive system. In addition, each lens contains a separate motor called the EMD (Electro-Magnetic Diaphragm) to control the aperture.

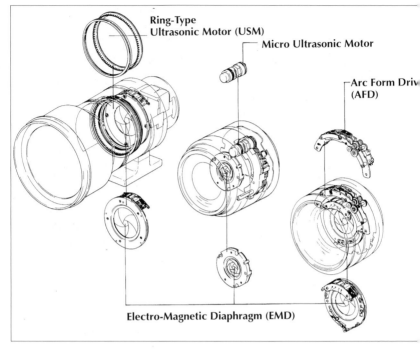

Ring-Type Ultrasonic Motor (USM)

Micro Ultrasonic Motor

Arc Form Driv (AFD)

Electro-Magnetic Diaphragm (EMD)

Canon's AF lens motor and aperture system.

Using Perspective Creatively

Interchangeable lenses are essential to the unparalleled versatility of single-lens-reflex cameras. This involves not merely adapting to various situations, but enjoying real creative freedom. Each focal length shows the world in its own way, allowing almost infinite variations in your images.

Let's be clear. Focal length does not create perspective. As long as you and your subject are stationary, changing the focal length will only alter the cropping of the image. The perspective will be the same in each and every shot. If you doubt this, try shooting the same scene with a wide-angle and a telephoto lens. Then enlarge the center of the wide-angle picture until it matches the composition of the tele image. You will see that the image quality suffers, but the perspective remains constant.

A 20mm lens was not the best choice to photograph this statue detail. To fill the frame with the lion, the photographer had to get close to the statue, which caused distortion. The wide-angle lens' extensive depth of field produced a distracting background.

Here the lion was shot with a 200mm lens. The background and foreground are compressed, and the background is blurred by the shallow depth of field, both characteristic of longer focal length lenses. The blurred background frames the subject nicely, creating a well-balanced composition.

You may think the main purpose of telephoto lenses is to bridge distances, and that wide-angles are intended for encompassing large spaces. This is all true, but it's not the whole story. The fascinating aspect of interchangeable lenses is the visual effects they can produce based on the different ways in which they are used.

Wide-angle lenses tend to be focused at comparatively close distances. This creates the appearance of an isolated foreground subject, with the background seemingly far away. The effect is easily understandable, if you consider that the background may be 10, 20, or 100 times farther from the camera than the foreground subject.

Conversely, telephoto subjects tend to be much farther from the camera, so the relative distance between the foreground and the background is not as great. That's why the foreground object

A zoom lens offers the ability to try different compositions quickly and easily. The placement of elements in this photograph is not terribly interesting. The plant, the truck, and the cobblestone house all appear to be of equal importance.

By lowering the camera's position and zooming to a longer focal length, the photographer was able to connect the individual elements. The plant commands a dynamic place in the foreground, drawing attention to the house and giving the photo a sense of depth.

appears very close to the background, even if that is not actually the case. While only a small portion of the background is visible, this section is so enlarged that it no longer seems far away.

Here's an experiment for you to try. Shoot an object with a 20mm lens from about five feet (1.5 m) away; then take a second shot of the same thing with a 200mm lens, from 50 feet (15 m) away. The wide-angle image intensifies the impression of depth, while the telephoto shot appears flatter and more uniform. By picking different lenses and shooting positions, you can literally bend the world into any shape you desire!

Color Correction

An optical element acts like a prism. It separates light passing through it into wavelengths that we see as colors. This rainbow effect may be pretty in a prism, but for a photographic image, it is deadly. If the individual wavelengths do not converge on a single plane, we will see various colors where there should be only white light. Left uncorrected, the focal point for purple is in front of the one for green, which in turn is in front of red. The picture therefore cannot be sharp, because the individual colors overlap to produce a soft mass rather than a pinpoint dot.

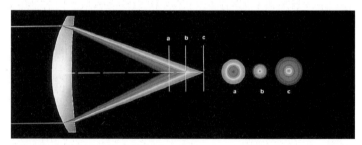

When light passes through a convex lens, individual colors, or wavelengths, of light intersect at different points. This results in color fringing and focusing problems.

Two elements made of different types of glass can bring two colors to the same point of focus, called an "achromatic" correction. What remains is the so-called secondary spectrum of residual color aberration. This becomes more noticeable as the focal length increases, posing great challenges to designers of telephoto lenses.

Canon was the first manufacturer to successfully grow calcium-fluorite crystals large enough to be used in constructing telephoto lens elements. This fluorite material is renowned for its extremely low dispersion, which means that the focal points of the individual colors lie very close to each other. "Apochromatic" correction is therefore possible, greatly reducing the remaining color aberrations by correcting for three wavelengths of light.

LD (Low-Dispersion) glasses with fluorite additives appeared a little later. These demonstrated characteristics similar to fluorite crystals, but were far easier to produce, and hence more economical. Both materials are used in today's EF lens line-up. The result is long focal-length lenses with impressive sharpness, contrast, and color rendition.

Aspherical Elements

Glass elements have another unpleasant characteristic: they bend light rays at the edge more than those at the center. Unless this is corrected, the rays come into focus on different planes. The effect

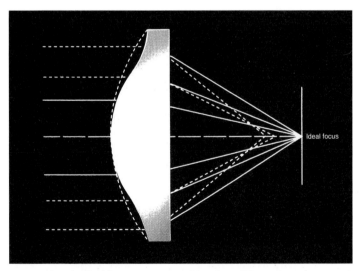

Ideal focus

A normal, spherical lens (represented by dotted lines) focuses rays of light coming from the outer edge of the lens at a point in front of those passing through the center of the lens. An aspherical surface is required in order to focus all rays of light on the same plane.

is called "spherical aberration," and it reduces sharpness and contrast while increasing flare. Spherical aberration is most pronounced with large-diameter elements, so fast lenses are particularly at risk.

You can reduce spherical aberration somewhat by stopping down the diaphragm, but this will not totally eliminate the effect. Also, shooting at small apertures rather defeats the purpose of having a fast lens. A better solution is for the manufacturer to shape lens elements aspherically, rather than in the usual continuous arc, so that edge and center rays will focus on the same point. Aspherical elements cannot be constructed using conventional grinding methods, however, and were only a dream of lens designers for many years.

To make them practical, Canon has invested more than two decades of research and development. Today Canon creates aspherical elements by grinding and by molding, as well as by combining the two manufacturing techniques. These once-exotic elements are used not only in super-fast lenses, but also in the design of compact, lightweight, and economical zooms.

Internal Focusing
Canon's introduction of Internal Focusing (IF) in long focal length lenses was another significant breakthrough. Instead of moving great masses of glass and metal, focusing could now be achieved by adjusting only a small group of elements at the rear of the light path. Only the front section has to be large, while the rest of the housing is small and slim. The barrel remains fixed during the focusing operation, so the center of gravity does not shift. Also,

Internal focusing on the EF 100mm f/2 USM. Rather than all the elements moving to achieve focus, only the center (most darkly shaded) element moves along the axis during focusing.

the focusing movement becomes much smaller and simpler, yielding shorter close-focusing distances and improved close-up performance.

Today, various types of internal focusing are used in about half of the EF lens line. Like aspherical elements, this design was originally restricted to powerful telephoto lenses and zooms; it is now found in compact, lightweight lenses with non-rotating filter mounts.

Ultra Wide-Angle Lenses

As a somewhat arbitrary convention, any lens with an angle of view of 90° or greater (measured across the diagonal of the film frame) is considered an ultra wide-angle. These exotic and expensive lenses "see" far more than the human eye can sharply encompass at any given moment. Perhaps that's why ultra-wides can be the most difficult lenses for the beginner to master. If used carelessly, an ultra wide-angle lens can create unpleasantly egg-shaped images of people's heads and combine totally unrelated subjects in the same picture. When used for landscapes, they can easily include extremes of light and shadow that are beyond the latitude of any film.

Once you get the knack, however, using an ultra-wide is nothing short of visual liberation. You can cover almost any interior, without having to back up onto the fire escape. Mighty mountains and soaring skyscrapers are brought into view, minus the annoying "falling back" effect created by pronounced camera tilt. Best of all, foreground and background objects can be visually related, with every inch rendered in sharp focus.

The Canon EF lens system offers three ultra wide-angle lenses with fixed focal lengths and a pair of zooms that extend into the ultra-wide range. By far the widest angle of view, an awesome 180°, is offered by the **Fish-Eye EF 15mm f/2.8** lens. This is a full-frame fish-eye, so although straight lines are curved (except the line traveling precisely through the center of the image), the whole image does not look like a reflection in a Christmas tree ornament. Unlike some of its peers, focusing is automatic and speed is more than sufficient.

Although similar to the fish-eye in focal length, the **EF 14mm**

f/2.8L USM is a rectilinear wide-angle, which means that straight lines remain straight throughout the image. The "L" designation signifies Canon's high-end "Luxury" lens series, in this case incorporating a large-aperture, aspherical element for maximum sharpness and minimum distortion over the 114° field of view. Like many EF lenses, this one incorporates a USM (ultrasonic motor) for particularly quick, quiet focusing. Filters are built in.

If a little less angle will do (as it usually will), consider the **EF 20mm f/2.8 USM** lens. Significantly smaller and lighter than the 14mm, it includes a similar focusing motor, a floating lens element (for optimum correction throughout the focusing range), and a non-rotating front element (for ease of use with polarizers and split-ND filters). The 94° angle of view is a bit easier to handle than 114°, yet still wide enough to yield spectacular results.

In fact, if 20mm is your thing, the EF system offers two more choices. Among the few zooms that reach into this ultra-wide territory are Canon's non-identical twins: the **EF 20-35mm f/2.8L** and **EF 20-35mm f/3.5-4.5 USM.** Each spans the wide-angle range from ultra (94°) to moderate (63°), effectively providing all the wide-angle capability that most photographers will ever need.

Like many siblings, these two differ in important ways. Available-light photographers will appreciate the fixed, fast f/2.8 maximum aperture of the "L" version, which also features an aspherical element and a non-rotating front end. Those on a budget may opt for the more compact, relatively inexpensive USM model. Although it has a slower, variable, maximum aperture, this newer design offers quiet USM focusing.

A fish-eye lens "bends" straight lines, but the effect here has been minimized by the curved elements in the photo. To avoid obvious distortion, place strong horizontal and vertical elements close to the center of the frame. ⇨

Wide-Angle Lenses

As it does in virtually every range, the Canon EF system offers a healthy selection of wide-angle lenses in both fixed focal-length and zoom types. Years ago, there was no real choice—the discerning photographer would choose a fixed 35mm lens for everyday candid shooting, a 28mm for interiors, and perhaps a 24mm for landscapes. These lenses were small, light, fast, and sharp; everything that zooms were not.

Although today's fixed focal length lenses are better than ever, zooms have progressed at an even faster rate. Thanks to high-speed computer design programs, fancy glass, aspherical elements, and multi-layer coating, modern zooms are good enough to satisfy most photographers most of the time. Zooms still tend to be relatively slow, but that's not much of an issue for those who shoot fast film or work extensively with flash. Even the variable maximum aperture design, which used to make light metering difficult, is now handled automatically by TTL (Through-the-Lens) meters.

For EOS photographers who prefer traditional optics, four fixed focal length wide-angles are available: **EF 24mm f/2.8**, **EF 28mm f/1.8 USM, EF 28mm f/2.8**, and **EF 35mm f/2.** Angles of view are 84°, 75°, 75°, and 63°, respectively. Optical designs are fairly conventional, except for a molded aspherical element in the fast, pro-oriented 28mm f/1.8. Before jumping to the zooms, consider that these tried-and-true optics have some real advantages.

Each of the fixed focal length wide-angles weighs less than 11 ounces (312 g), measures under 2-1/4 inches (56 mm) in length, and focuses to one foot (0.3 m) or closer. The maximum aperture is at least as fast as any zoom, and faster in the case of the 35mm f/2 and 28mm f/1.8. Do they still outperform the zooms where it counts—on the image itself? There is no simple answer, but here's a thought. The 28mm f/2.8 lens has only five elements, about half as many as a comparable zoom. All else being equal, fewer elements mean less flare, an important advantage when shooting sundrenched landscapes or brightly lit interiors.

The recipe for "dynamic" skyscrapers? Use a short focal length, the shorter the better. This was taken with a 20mm lens. Position yourself close to the building and tilt the camera up at a steep angle. An interesting detail in the foreground adds an exciting element to the photograph.

Use a long focal length lens to take an intimate portrait without getting too close to the person. If you keep your distance, your subject will be more relaxed and less conscious of the camera.

Take a second look at an all-too-familiar beach. Mount the shortest focal length lens you have on your camera. And then get as close as you dare. The foreground suddenly fills the majority of the frame. Set Aperture-Priority mode and choose a small aperture for sharp focus throughout the entire scene.

This is exactly the type of subject that should be photographed using the Portrait program mode. The photographer can concentrate on capturing the little girl's expression. The camera will set exposure, choosing a large aperture to reduce a distracting background to a soft blur.

Don't use a focal length shorter than 135mm for portraits. You don't ⇨ have to get terribly close to your subject. Quite the contrary, your pictures will be better if you stand a little farther away. Fill the frame as much as possible and use a wide aperture. The background will become a blur. Use the built-in flash on the Elan II/IIE to put catchlights in the subject's eyes and soften the shadows.

Interesting subjects can appear at any moment. The light on this window display created lovely shadows, giving depth to the objects. Again, framing and composition make all the difference to a shot like this. Unlike many point-and-shoot cameras, the Elan II/IIE's autofocus system can focus through a pane of glass unless it is very dirty. But be careful to watch for reflections, because they will show up in your photo!

The trained eye will often see subjects like this that just cannot be resisted. Light and color combine to make a rich image, leaving framing all that's left to do.

Wide-Angle Zooms

The great advantage of zoom lenses is convenience. It's a lot easier to carry one or two zooms than a bagful of fixed focal length lenses, and you are more likely to have the right focal length available if an unanticipated subject suddenly appears. When shooting inaccessible subjects, or when shooting from a fixed position, zooms allow more precise composition than would otherwise be possible. This is particularly important with color slides, which are usually projected uncropped.

As a testament to the popularity of wide-angle zooms, the Canon EF system offers a remarkable choice of *nine* zoom lenses with wide-angle capabilities (plus the two ultra-wide 20-35mm zooms). Three start at 28mm, with ranges to 70, 80, and 105mm, respectively. The other six begin at 35mm and extend to 80, 105, 135, or an astonishing 350mm. If any type of lens can be said to do everything, the wide-angle zoom has got to be the one.

This versatility is what draws so many buyers of the Elan II/IIE to start out with the compact **EF 28-80mm f/3.5-5.6 III USM** zoom rather than a normal 50mm lens. The focal length range, encompassing true wide-angle, normal, and portrait tele, makes this an ideal lens for all-around picture-taking. Angles of view range from 75° to 30°. The lens is lightweight enough to

EF 28-80mm f/3.5-5.6 USM

▷ Taking a natural-looking picture of your child doesn't have to be a challenge with the Elan II/IIE. Use a telephoto lens around 200mm. Then select either the Portrait program or Aperture-Priority mode and set the largest aperture. The camera will take care of the focus and exposure setting for you. So all you have to do is wait for the right moment and shoot.

balance perfectly on the Elan II/IIE body, and it offers a surprising dose of high-tech for a reasonably priced optic: ultrasonic motor, aspherical element, and macro-focusing capability. The "III" designation means this is the third generation EF lens of this focal length and aperture range.

If speed is more important than reach, try the **ED 28-70mm f/2.8L USM.** This "luxury" lens is far bigger in price, size, and weight than its economical counterpart, but the payoffs are a consistently fast maximum aperture and absolutely superb optical performance. Or, if a little more telephoto power is required, the logical choice is the **EF 28-105mm f/3.5-4.5 USM.** Its angle of view at the long end is a relatively narrow 23°, powerful enough for tight head-and-shoulders portraiture from a comfortable shooting distance. Its zoom range is almost 4x, sufficient for anything a weekend will bring your way.

Like animals on the Ark, some EF zooms come in pairs. For example, there is the **EF 35-80mm f/4-5.6 USM** and the recently introduced **EF 35-80mm f/4-5.6 III.** Each is a compact, lightweight zoom with a range from medium wide-angle to medium telephoto, and macro-focusing capability. The major difference is in the focusing motor: advanced USM in the more high-end version, and an inexpensive "belt drive" motor in the price-leader model. Either one is a fine "normal" lens, but (according to author SP) the wider range of the 28-80mm zoom makes it an even better all-in-one optic.

Another zoom duo offers a little more reach: the **EF 35-105mm f/4.5-5.6 USM** and the **EF 35-105mm f/4.5-5.6.** Each has an aspherical element and macro focusing. Again, the major difference is in the focusing motor—ultrasonic vs. micro motor. USM is faster, quieter, and a bit more expensive. It's your money....

Actually, for my money (author SP, again), I would go with the 28-105mm in preference to either of these. It's a little longer and heavier, but the minimum focusing distance is even closer, the maximum aperture is bigger, and the 28mm focal length offers 12° more coverage. That makes a big difference on the open plains

A wide-angle lens is an excellent choice for shooting interiors. A diagonal orientation produces converging lines that lead the viewer into the photograph. Even though a large aperture was used in the minimal available light, the photo has exceptable sharpness from foreground to background. ⇨

or in a cramped room. The built-in flash of the Elan II/IIE covers the 28mm field of view, so why not take advantage?

Still more telephoto power is available in the **EF 35-135mm f/4-5.6 USM.** The angle of view narrows to 18°, with a 2.7x magnification that is sufficient to pick out architectural details on nearby buildings. In addition to the desirable USM, this lens features an aspherical element, macro focusing, and a non-rotating front element.

Of course, the photographer who wants *everything* has to reach for the moon, or more specifically the **EF 35-350mm f/3.5-5.6L USM.** No, it's not a typo; the lens really exists, and it works remarkably well. About seven inches (17.8 cm) long, and weighing in at three pounds (1.4 kg), this optical marvel has a 10x focal-length range—more commonly found on a camcorder than on a 35mm SLR. One mighty zoom takes you from 63° wide-angle to 3-1/2° super telephoto, replacing about eight fixed focal length lenses. This is the ideal choice for the photographer who never wants to change lenses.

Normal Lenses

In photography, as in so many areas of life, "normal" is defined by what most people like. By that criterion, the traditional 50mm lens has not been normal for quite awhile. As mentioned earlier, the wide-angle to medium telephoto zoom is the lens usually sold with modern SLRs. It offers far more flexibility than a fixed focal length lens, albeit with less speed and at a higher price. So why consider a 50mm at all?

Each EF normal lens has its own *raison d'être*. And actually, normal lenses are so called because they approximate the angle of view of the human eye (45° to 53°), hence offering a "normal" view.

The most conventional normal lens is the **EF 50mm f/1.8 II.** It is also the most compact and least expensive lens in the entire EF system. It weighs less than five ounces (142 g)! It doesn't sport any fancy optical or electronic technology, perhaps, but this little lens gives tack-sharp images over an eminently usable 46° angle of view. The f/1.8 speed is nothing special for a 50mm, yet a full two stops faster than the typical zoom. That extends the available-light

capability of your favorite film and doubles the distance range of any flash. Not bad for a fistful of dollars.

Moving up the scale, we come to the **EF 50mm f/1.4 USM**—a little larger, 2/3 stop faster, and equipped with an ultrasonic focusing motor. Like its small sibling, this speedy lens focuses continuously to 1.5 feet (0.5 m), which is fine for medium-close work. (But don't use a 50mm for full-face portraits, unless you prefer Cyrano-style noses.) And f/1.4 is fast enough for almost any lighting condition.

If that still isn't enough, the **EF 50mm f/1.0L USM** is the fastest normal lens ever made for an SLR. It is a full stop faster than the f/1.4, almost two stops speedier than the f/1.8, and about four stops quicker than a typical zoom. Aspherical elements and a floating-element design maximize sharpness, even wide open, which is how this pricey lens will be used. At that aperture there is precious little depth of field, so the background will be completely soft and unobtrusive. Used with fast film, this lens lets you shoot indoor sports at shutter speeds high enough to freeze action without flash. The USM focusing motor, combined with the Elan II/IIE's quick AF system, ensures that the point of focus will be where you want it to be.

Medium Telephoto Lenses

Medium-power or "short" telephoto lenses bridge the gap between the "normal" range and true space-spanners. They tend to be compact enough for comfortable hand-holding and fast enough for available-light work. With angles of view from 28.5° (for an 85mm lens) to 12° (for a 200mm), medium teles perform a most valuable function: in-camera cropping of extraneous details. Switch from a 50mm to a 135mm, for example, and you're forced to decide what the real subject of each picture is.

The Canon EF system includes some of the fastest telephoto lenses on the market, which share much technology with the remarkable 50mm f/1.0L. In fact, the second fastest lens in the system is the **EF 85mm f/1.2L USM.** As it happens, these two lenses are very similar in physical appearance, and they both have aspherical elements, an advanced optical system that "floats" elements as it focuses, and of course the ultrasonic AF motor. The

An 85mm f/1.8 lens at maximum aperture was just perfect for this night shot. Shallow depth of field didn't matter given the subject's distance.

85mm focal length is better suited to head-and-shoulders portraiture, and its wide aperture can easily reduce the background to a beautiful blur. Other logical uses are for shooting indoor sports and outdoor scenics after sunset.

Naturally, the 85mm f/1.2 is quite expensive, and not everyone absolutely needs that last drop of speed. If you can live with about a stop less, the **EF 85mm f/1.8 USM** lens is smaller, lighter, and considerably less costly. The ultrasonic motor and floating-element design are just as effective, the minimum focus is a little closer, and the filter size is only 58mm (versus 72mm). Although this lens was designed specifically for the EF system, Canon has been making fine 85mm f/1.8 lenses since the days when bell bottoms were first considered hip.

A reasonable alternative to the 85mm f/1.8 is the **EF 100mm f/2 USM,** which trades off a tiny bit of speed for a touch more magnification. With an angle of view of 24°, this lens is a fine

choice for dramatically tight, head-only portraits. It's still fast enough for indoor sports and portable enough (at 16 ounces [460 g]) to haul around all day. Technical details are similar to those of the 85mm f/1.8, including a non-rotating front and a 58mm filter mount.

The next member of this group is the **EF 135mm f/2.8 Soft Focus,** a lens with a split personality. On the one hand, it's a fast telephoto of 2.7x magnification (compared with 50mm) and an 18° angle of view well suited for landscapes or candid portraits on the street. The other identity is as a soft-focus portrait lens, with the degree of softness adjusted on a continuously variable ring. Aperture width also affects the soft-focus look, which is most pronounced with the lens wide open. Unlike many such designs, the 135mm f/2.8 is tack sharp in its normal mode; the soft-focus feature is simply a welcome bonus.

For most photographers, 200mm is the longest focal length to be considered a medium telephoto. With a 12° angle of view, it is powerful enough for some wildlife and outdoor sports photography, yet still permits easy carrying and handheld shooting. The EF system offers two speedy choices in this focal length, the **EF 200mm f/1.8L USM** and the **EF 200mm f/2.8L USM.** As usual, the tradeoff is between maximum speed and maximum mobility. Although neither lens is inexpensive, the f/2.8 is by far the more affordable of the two.

Both models have every technical tweak imaginable, including ultra-low dispersion (UD) glass, but the f/2.8 has the advantage of focusing closer (five feet versus eight feet [1.5 to 2.4 m), and weighing about a quarter as much. It is still faster than most zooms, and offers a nice, bright viewfinder image. There are situations, however, where only pure horsepower will do. For shooting a dark-colored beast in the shadows or a football player on a miserable, rainy day, f/1.8 can be a lifesaver.

Telephoto Zooms

The only type of lens as popular as the wide-angle zoom is the telephoto zoom. These lenses offer the same advantages of the medium telephotos—convenience and precise cropping—but there is a conceptual difference. The wide-angle zoom spans

different optical genres (wide/normal/tele), while the telephoto zoom offers a range of magnification within a single realm. (There are a few normal-to-telephoto lenses on the market, but nobody seems to buy them.)

Attesting to the popularity of tele zooms, the EF line includes *nine* of them! The tele zooms start at 70, 75, 80, or 100mm, and extend to 200, 210, or 300mm. The fastest of the group has a constant maximum aperture of f/2.8, the slowest is f/5.6 throughout. The others have variable maximum apertures. There are technical differences as well, and significant variations in magnification range. Yet all of these lenses can be considered "do everything" teles, useful for travel, landscape, portraiture, and some sports or nature subjects. Virtually all are hand-holdable, and most are reasonably affordable. If you intend to buy only one telephoto lens, definitely check out this category first.

As we mentioned earlier, Canon tends to offer its zoom lenses in pairs. Within each duo, both lenses have an identical (or virtually identical) focal length range, but differ in maximum aperture and degree of technical sophistication. So it is not surprising that the nine tele zooms include three pairs of twins—and one set of triplets!

The first duo consists of the new **70-200mm f/2.8L USM** and the **70-210mm f/3.5-4.5 USM.** The fast 70-200mm is actually an update of the previous 80-200mm f/2.8L, now with a slightly wider zoom range and an ultrasonic motor. As a member of the "L" series, the 70-200mm is rather expensive, but if its optical performance simply matches that of the earlier lens, critical users will be quite happy. And focusing is sure to be faster, thanks to the new motor. The same ultrasonic focusing system is available in the 70-210mm zoom, along with internal focusing and a non-rotating filter mount. The slower lens is much smaller, lighter, and less expensive as well.

A longer focal length lens, such as the 135mm used to take this photo, ⇨ **offers a narrow angle of view so you can crop out unwanted elements and isolate the main subject. The longer focal length allowed the fountain to fill the background of the frame while the photographer maintained a comfortable distance from the women.**

Perhaps you want a zoom with a little more reach, to photograph the high school football game or a reticent deer. If so, a good choice is the **75-300mm f/4-5.6 II USM**. This newly revised, 17-ounce (495 g) lens offers angles of view from 32° to 8° and fast focusing to five feet (1.5 m); its filter size is only 58mm.

Two other variations on this focal length theme are also available. The **75-300mm f/4-5.6 II** is a less-expensive version, with a conventional micro motor rather than ultrasonic AF. And the remarkable **75-300mm f/4-5.6 IS USM** incorporates Canon's unique "Image Stabilization" system. This combination of optical and electronic technology actually compensates for camera and lens movement, extending the shutter speed limits of handheld photography. (By the way, Image Stabilization and Eye Controlled Focus are available on Canon camcorders as well as on EOS cameras.)

EF 70-200mm f/2.8L USM

Telephoto zooms are great for traveling. The longer focal length helps you capture interesting subjects from a distance. Intriguing snapshots can be taken that wouldn't have been possible with a normal lens.

EF 75-300mm f/4-5.6 IS USM

The **EF 80-200mm f/4.5-5.6 USM** is by far the most compact Canon tele zoom, measuring about three inches (78 mm) in length and weighing only nine ounces (260 g). It's ideal for travel and for arduous backpacking.

Although this lens is rather slow, you'll find that carrying high-speed film is a lot easier than schlepping a big hunk of glass and metal. The 80-200mm zoom covers a range from 30° to 12°, and even includes close-focusing to capture the occasional wildflower by the trail. If you can trade off a bit of focusing speed, the inexpensive **EF 80-200mm f/4.5-5.6 II** uses a belt drive in place of the ultra-sonic motor.

Finally, we come to a rather exotic pair, the **EF 100-300mm f/5.6L** and the **EF 100-300mm f/4.5-5.6 USM.** Contrary to usual Canon practice, the

EF 80-200mm f/4.5-5.6 USM

techno goodies are divided among both lenses. The f/5.6 lens, which you might expect to be a stripped-down model, is a

legitimate member of the "L" series. Its optical system boasts an advanced fluorite element and UD glass for image quality that rivals a fine fixed focal length lens. If very fast focusing is more important, however, the compact f/4.5-5.6 version has a USM motor, plus a non-rotating front element for optimum use of polarizers and graduated ND filters. Both lenses offer macro focusing as well. Logically, the "L" version should incorporate a USM, and the next version is sure to have one.

Super Telephoto Lenses

We are now in the realm of serious glass, suitable for stadium sports or stalking the wild rhinoceros. Some people also spy on their neighbors, although the less said about that the better. This range, from 300mm to 1200mm, requires a tripod (or perhaps a monopod if you're adept), fast shutter speeds, and fast film. Magnification is 6x to 24x compared with a 50mm lens, and angle of view ranges from about 8° to 2°. We're talking tele!

The seven lenses in this group are: **EF 300mm f/2.8L USM, EF 300mm f/4L USM, EF 400mm f/2.8L USM, EF 400mm f/5.6L USM, EF 500mm f/4.5L USM, EF 600mm f/4L USM,** and **EF 1200mm f/5.6L USM.** As you can see, all seven are part of the "L" line, and all feature USM autofocusing. They have much else in common: UD glass elements, internal focusing, non-rotating front elements, and a focusing-range selector. The latter is a device that lets you divide the focusing range into sections, such as "closer than 50 feet (15.2 m)" and "50 feet to infinity." By restricting the range, you help the AF system find the actual point of focus that much faster.

One might consider the 300mm f/2.8L and f/4L lenses to be the "babies" of this group, for they weigh in at a mere 6.3 (2.9 kg) and 2.9 pounds (1.3 kg), respectively. In fact, the slower lens is hand-holdable if you are strong and steady enough. Both lenses have smooth manual focusing, which is a real advantage with seriously off-center or low-contrast subjects. Their 8-1/4° angle of view is fine for tennis or hockey, but probably a little short for football. (The **Canon Extender EF 1.4x** or **Extender EF 2x** can easily remedy the shortfall.) And the f/2.8 version, in particular, throws the background pleasingly out of focus.

Canon introduced a manual-focusing 400mm f/2.8 lens back in 1980, and professional sports photographers immediately adopted it as their own. The current EF version is optically identical to the original lens, with two ultra-low dispersion elements to minimize chromatic aberrations, of particular concern with long, fast lenses. With the addition of USM autofocusing, the EF lens is even better suited to fast action than was its famous predecessor. Attach an EF extender to this lens, and you get a 560mm f/4 or an 800mm f/5.6, still with autofocus and autoexposure operation.

If handheld shooting (or backpack hauling) is more important than lens speed, the 400mm f/5.6L USM is an obvious choice. It is about 3-1/2 inches (9 cm) shorter, and almost 11 pounds (5 kg) lighter than the f/2.8 version. (Naturally, the price is smaller as well.) In fact, the 400mm f/5.6 is not much longer, and slightly lighter in weight, than the 300mm f/4. Even so, holding a camera steady with an 8x magnification telephoto is not an easy task.

Our history lesson resumes with the 500mm f/4.5L USM, a direct descendent of a manual-focusing lens introduced during the Carter administration (late 70s/early 80s). This updated oldie is a goody, with rear-focusing design and one each fluorite and UD glass element. Despite its power and speed, the 500mm f/4.5 is surprisingly lightweight (6.6 pounds [3 kg]) and small (15 inches in length [39 cm]). It may be a bit much to hand-hold, but at least you won't get a hernia hauling the lens to the ballpark or into the woods.

A more recent entry is the 600mm f/4L USM, developed specifically as an autofocus lens for the 1988 Calgary Winter Olympics. Endowed with one fluorite element and two UD glass elements, this stovepipe yields images of remarkable clarity and contrast. The addition of an Extender 1.4x converts it into an autofocus 840mm f/5.6; with the Extender 2x you get a manual-focusing 1200mm f/8.

If still more optical power is needed, try the local observatory or the slightly more compact 1200mm f/5.6L. This special-order Canon cannon measures 33 inches (83.6 cm) long, and weighs in

Use a macro lens to turn an everyday object into an abstraction. A detail ➪ from a piece of pottery becomes a beautiful subject in the blink of an eye.

at a svelte 36 pounds (16.5 kg). Despite all that bulk, an ultrasonic motor provides fast autofocusing for subjects at least 46 feet (14 m) away. The 24x magnification is actually too powerful for most sports shooting, but it would be a natural for close-ups of a space shuttle launch. Or you could check whether the man in the moon has a clean shave.

Macro Lenses

The term "macro" is often applied to lenses, especially zooms, that offer closer-than-usual focusing. Strictly speaking, however, a macro lens must focus close enough to reproduce the subject at least 1/2 life-size on film. This is referred to as 0.5x magnification; full life-size is 1x. (By comparison, most so-called "macro" zooms offer only about 0.25x reproduction.) Macro photography of two-dimensional subjects also requires an optical field that is flat from corner to corner, which is seldom found on a close-focusing zoom. By these criteria, Canon offers two real macro lenses.

For a different approach to the 50mm focal length, consider the **EF 50mm f/2.5 Compact Macro.** Here the focus is not on speed, but on optimum performance in the extreme close-up range. Unlike a conventional lens fitted with a bellows or close-up attachment, the 50mm f/2.5 focuses continuously and automatically from infinity to its close limit of 0.5x (1/2 life-size). Attach the **Life Size Converter EF,** and the lens focuses automatically over the range from 1/4 to full life-size. Without the converter, sharpness is excellent at normal distances as well. This lens is a fine choice for nature photographers, stamp collectors, or anyone who wants a very close-focusing 50mm.

Another multi-use optic is the **EF 100mm f/2.8 Macro.** This unusual tele focuses continuously from infinity to one foot (0.3 m) providing full life-size images on film without the need for accessories. And the longer focal length, compared with a 50mm macro, provides more working room between the lens and the subject. This greater distance makes it easier to light your subject and often provides a more pleasing perspective. Optical performance at all distances is enhanced by a floating element, so portraits and scenics will be as sharp as macro subjects. A non-rotating front element simplifies the use of filters.

Tilt-Shift Lenses

Of all the lenses in the EF system, surely the most unusual are the trio of Tilt-Shift lenses, the **TS-E 24mm f/3.5L, TS-E 45mm f/2.8,** and **TS-E 90mm f/2.8.** These lenses replicate two of the most valuable movements of a large-format view camera, namely tilting and shifting. While shifting is available in a few non-Canon 35mm-format lenses, tilting is unique to the TS-E set. Books have been written about these complex functions, but we will only sketch the outlines.

Canon's TS-E lenses help you avoid converging lines by tilting the optical system.

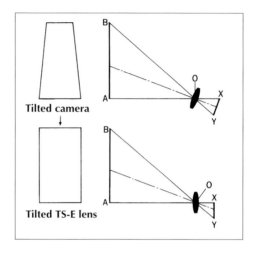

Because the plane of focus of ordinary lenses is parallel to the film, maximum depth of field is available for subjects that are parallel to the film as well. A good example might be the wall of a building, which is parallel to you, and all of which can be easily rendered sharply on film. But what if the camera is angled at 45° to the wall, to create a more interesting picture? Depth of field may be inadequate to render it all sharply, no matter how small the lens aperture.

A tilt lens, however, lets you adjust the plane of focus so it is parallel to the subject, rather than parallel to the film. If the lens is tilted at the same angle as the wall, the entire wall will be rendered sharply, even if a wide aperture is used. Conversely, if you tilt the lens so that it is perpendicular to the wall, depth of field

will be radically reduced, dramatically highlighting the extremely narrow plane of sharpness.

Shifting is an elegant way to correct a subject's apparently converging lines so they look parallel in the image. When using a conventional lens to photograph a building, for example, you often have to tilt the camera backward to include the whole structure. The walls seem to converge, giving the building the unpleasant appearance that it is falling backwards. With a TS-E lens, you can keep the camera parallel to the building and shift the optical axis of the lens upward instead. It is as if you had moved the entire camera far higher, to take in the whole building without distorting its geometric relationships. For optimum image quality when shifting, TS-E lenses are designed to project a much larger-than-usual image on film.

Of course, tilting and shifting are best done with the lens on a tripod-mounted camera. In order to accommodate the complex gearing needed for these movements, TS-E lenses offer only manual focusing. Since they are unlikely to be used for quick shooting, this is not a significant drawback. The 24mm "L" lens has an aspherical element and a floating element as well. The 45mm lens offers internal focusing, and all three have non-rotating front elements.

Do You Need Filters?

These days, most photographs are shot on color film, so there's little need for the classic yellow, orange, red, and green filters of the black-and-white era. Yet a few filters are still worth considering for color work. Filters are available from Canon or from accessory filter manufacturers.

Ultraviolet Filters
At the top of the list is the ultraviolet (UV) filter, which can be left on the lens all the time, as it neither absorbs light nor shifts colors. This filter helps protect your lens' front element from becoming dirty or damaged. Equally as important, it protects the front barrel of the lens from dents caused by collisions with rocks, car doors, or similar obstacles while the camera is transported by its neck strap (an all-too-common, costly lens repair).

A UV filter does absorb some UV radiation, which causes skies

to appear washed out or distant scenes to decrease in sharpness. A UV filter is recommended anywhere that UV radiation is more prevalent, such as at high altitudes and at the ocean. Because the camera's exposure meter does not read UV radiation but film is sensitive to it, without a good UV filter, high-altitude or seaside exposures may be slightly overexposed.

A filter does, however, add two reflective glass and air surfaces to the optical system. Some purists therefore avoid leaving filters on permanently. But as long as you employ multi-coated filters (such as those in the Canon line), a compromise is possible—use the filter to reduce UV or to protect the front element. But remove it under unfavorable lighting conditions, such as backlighting, to avoid flare.

Skylight Filters

Another popular choice as a "protective filter" is the skylight filter, a close relative to the UV filter. This filter also absorbs UV radiation, and its faint pinkish tinge introduces a slight warming effect. The main purpose of a skylight filter is to reduce haze in the far distance; it also counters the blue tint that some slide films display in overcast light or shadows. A skylight can also be used to add a bit of warmth to flash photos, which many photographers find desirable.

Neutral Density Filters

To force longer exposure times or to reduce the amount of light entering the lens, use neutral density (ND) filters. Canon and many other manufacturers offer these in ND4 and ND8 types, which reduce the amount of light by two and three stops, respectively, without affecting color rendition. Neutral density filters are useful in reducing the shutter speed for motion-blur effects, and are often used to photograph brightly lit landscapes with flowing water.

A related filter, the graduated ND type, reduces light gradually over part of the image area. Many photographers use this filter for increasing the color saturation of the sky in landscape photos. These are available from most accessory filter manufacturers. The Cokin® Filter System also offers graduated colored filters for painterly sky effects.

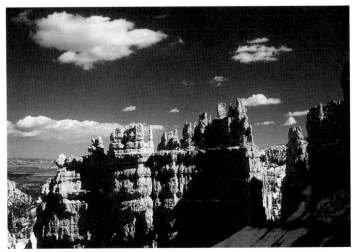

A polarizer reduces atmospheric haze, darkens the blue sky, and turns the clouds into cotton balls.

Polarizing Filters

The effects of a polarizing filter are almost magical if employed properly and selectively. The polarizer removes reflections and glare from surfaces and thus allows the full, natural color to come through. Saturation is greatly increased, and colors become deeper, particularly on sunny days. The blue sky darkens considerably, and white clouds "pop" like the ones on picture postcards and travel posters.

Polarizers come with rotatable mounts, so that you can adjust the polarizing effect. This is most pronounced at approximately 90° to the direction of the incoming light. The filter is practically useless, however, in backlit situations.

Because polarizers reduce contrast, they make it possible to create brilliant scenics without blown-out highlights. Reflections on non-metallic surfaces, such as water or glass, can be reduced or even eliminated, depending on the shooting angle.

A polarizer is usually required for photographs of objects behind glass. In the best-case scenario, you can make the glass disappear completely. This is especially useful for photographing framed artwork or a window display. Again, the purpose of the shot is the

deciding factor—is a glassless window the desired effect, or will it look unnatural?

At the usual rotation settings, a polarizer absorbs about 1-1/3 stops of light. If possible, use a faster film. Otherwise you will have to use a wider aperture (resulting in less depth of field) or a slower shutter speed (with less action-stopping ability). Either way, the exposure correction is accomplished automatically by the TTL metering system of the Elan II/IIE.

Be sure to purchase the right kind of polarizer! The Elan II/IIE requires the use of a circular polarizer such as Canon's Circular Polarizing Filter PL-C. There are also linear polarizers that will produce similar visual effects, but only a circular polarizer will work with the camera's sophisticated AF and light-metering systems.

Finally, a warning. Don't use more than one filter at a time! The increased weight may strain or even damage the lens' AF mechanism. And stacking multiple filters can cause image vignetting, especially with wide-angle lenses. If you are using a polarizer or a neutral density filter, take the time to first remove the UV or skylight filter if one is normally attached to the front of the lens.

Flash Photography

An abundance of advanced flash technology is incorporated into the Elan II/IIE. A multiple-zone metering cell is located at the bottom of the mirror box, aimed back toward the focal plane. It measures the light reflected from the film's surface while the shutter is open during the actual exposure. As soon as enough light has been received, the camera's flash is immediately turned off.

This internal metering setup allows two types of flash exposure control, which Canon refers to as TTL and A-TTL Auto Flash. These modes use the internal sensor's four zones to make readings weighted toward the active AF point.

A-TTL, available in the Full Auto and Program AE modes, offers a degree of balance between flash and available light. It works

Two of the four flash metering sensors are always linked together to better determine accurate flash exposure. The sensors are in turn linked to the active focusing point. This shows you how the sensors are weighted to the left, center, or right, depending upon the focusing point selected.

The Elan II/IIE's built-in flash comes in handy in situations when a little light is needed to illuminate what's in the shadows.

with the built-in flash and most dedicated flash units, *except* the 380EX. With this advanced model, the Elan II/IIE's six-zone evaluative meter takes over, integrating ambient light and flash in a system called E-TTL Auto Flash. (More details will follow.)

The Built-in Flash

Unobtrusively tucked away in the prism housing, the built-in flash is, of course, far less powerful than most accessory flash units. But this little unit is always available and ready to go at the press of a button. In the Full Auto, Portrait, and Close-Up AE modes, it even pops up automatically when needed. As long as you understand and respect the limitations of this small flash unit, it can be a valuable asset.

In any Creative Zone mode, when you press the flash button, the flash pops up and starts charging. To turn it off, just push the head back down. As mentioned earlier, the pop-up flash cannot be used along with an accessory flash unit; if *anything* is mounted on the accessory shoe, the built-in flash will not rise.

Guide Number and Range
Canon does not directly specify the built-in flash's range, but it is easy to figure out. Just start with the flash guide number, given as 43 in feet (13 in meters) for ISO 100 film. The equation is simple: guide number ÷ maximum aperture = maximum flash-to-subject distance.

Let's use the 28-105mm f/3.5-4.5 EF lens as an example. At the widest setting, the fastest aperture is f/3.5, allowing a maximum flash distance of about 12.3 feet (3.7 m) for ISO 100. At the telephoto setting, the f/4.5 opening permits a camera-to-subject distance of only about 9.5 feet (2.9 m). Keep in mind that it is not the focal length that affects the range of the flash unit. It is due to the zoom's variable aperture, which allows one stop less light to pass at 105mm than at 28mm.

At the middle focal length setting, around 60mm, this lens has an aperture of f/4, permitting a maximum flash distance of about 11 feet (3.3 m). That's just enough to deal with normal interior shots. If, on the other hand, you are using the flash for daylight fill, the maximum range is no longer critical. Even a weak flash

can still produce catchlights in the eyes and a hint of illumination in the shadows.

While you do not want to exceed the indoor distance limit with slide film, the increased exposure tolerance of color negative film allows a little more leeway. Just keep in mind that light diminishes at a rate inverse to the square of the distance it has traveled, meaning (in plain English) that it takes not two (as you might expect), but four times as much light to illuminate a subject at 20 feet than at 10 feet. In terms of apertures, that's two extra stops. So don't expect any miracles, and you will enjoy using the built-in flash.

Unlike some other small units, this one covers the full angle of view of a 28mm lens. If you use a shorter focal length, the image corners will be vignetted. Also, particularly big or fast lenses are not compatible, because their large-diameter barrels block part of the flash output, particularly with close subjects. For the same reason, you should avoid using a lens shade with the built-in flash.

And finally the minimum distance limit: You must stand at least 3 feet (1 m) from the subject to avoid uneven illumination and possible overexposure.

Sync Speeds

Most electronic flash units can only synchronize with focal plane shutters over a limited range of speeds. To understand why, we need to review how this type of shutter works.

A focal plane shutter, such as the one inside the Elan II/IIE, consists of two "curtains." The first curtain uncovers the image area to begin the exposure; then the second curtain follows it, ending the exposure. Whatever the shutter speed, these curtains always travel at the same rate. Shutter speed is determined by the length of time between the movement of the two curtains.

At fast shutter speeds, the second shutter curtain closely follows the first, and the image is exposed through a slit moving across the film. At progressively slower speeds, the slit becomes wider until the entire frame is exposed for a certain interval before the second curtain begins to close.

To create an evenly illuminated image, the flash must fire when the first curtain is fully open and before the second curtain begins to close. The fastest shutter speed at which the flash can expose the whole image area at once is commonly called the synchronization or "sync" speed. For the Elan II/IIE, this is 1/125 second. If

you could fire the flash unit with the camera set for a faster shutter speed, only part of the frame would be illuminated. To prevent such calamities, the Elan II/IIE automatically shifts to 1/125 second if you select a faster speed in one of the Creative Zone modes. (The Speedlite 380EX establishes a remarkable exception to the flash sync rules, as we shall see.)

The Elan II/IIE selects different shutter speeds, depending on the ambient light and the current exposure mode. In Program AE (P), the speed varies slightly, between 1/60 and 1/125 second. Far more latitude is available in the Aperture-Priority (Av) mode, which automatically chooses speeds from 30 seconds to 1/125 second to ensure background detail. (You can also use Custom Function C09, setting 1 to restrict Av flash sync to 1/125 second.) In the Shutter-Priority AE (Tv) and Manual (M) modes, the photographer can select shutter speeds of 1/125 second or slower.

The duration of the flash is not affected by the shutter speed. This means that the flash exposure will always be short enough to freeze the main subject if it is fairly close to the camera. Using slower shutter speeds allows the ambient light to have more effect on the exposure—generally a desirable arrangement that prevents dead-black, unnatural-looking backgrounds. But if the exposure is longer than about 1/15 second, you risk recording ghost images and streaky backgrounds. On the other hand, you may like the effect of a sharp main subject with a softly blurred background.

Red-Eye Reduction

In dim light, the pupils of both man and beast tend to open wide. Flash light can then bounce off the rear of the eyes, right back into the lens, turning your loved ones into red-eyed monsters. This effect is most pronounced if the flash is close to the optical axis of the lens, as is common on point-and-shoot cameras.

What can you do? Whenever possible, try to increase the level of ambient illumination so that the pupils contract. Avoid long lenses, which can increase the effect. Tell your subjects not to look directly into the lens. Or, to be safe, you can take advantage of the Elan II/IIE's red-eye reduction feature. Activate it by pressing the function button until the eye symbol appears on the LCD. Then use the Main Dial to set the function to "1" (on), and touch the shutter release to confirm the setting.

In this mode, you need a bit of patience. When you touch the

shutter release, vertical bars appear in the lower right-hand corner of the viewfinder, then they gradually disappear. While this is happening, the red-eye reduction lamp beside the flash reflector is shining into your subject's eyes, causing the pupils to contract. After about two seconds, when only one bar remains in the viewfinder, the desired effect should be accomplished. Then you can press the shutter release all the way down to make the exposure.

The red-eye reduction function remains in effect until you cancel it, even if the Elan II/IIE has been turned off. Whether you want to use it depends on your tolerance, and that of your subjects, for two-second delays. When photographing young children or other frisky creatures, lots of luck.

Flash Exposure Compensation

With the Elan II/IIE, you can even fine-tune the flash output. Perhaps the fill flash is too strong (or too weak) for your taste in certain situations—it can be changed in an instant!

To do this, press the function button until the flash exposure compensation symbol (a lightning bolt and +/-) appears on the LCD. Now enter the amount of correction desired using the Main Dial or the Quick Control Dial. Compensation is available over a range of +/-2 EV, in 0.5 EV increments, as displayed on the LCD's familiar exposure compensation scale. A brief touch of the shutter release confirms the setting and returns you to the current exposure mode.

$$^-2.1._{\boxed{0}}.1.2^+$$

←——— ■ ———→

The flash exposure compensation scale is clearly displayed on the LCD to show you the amount of compensation being set.

Unlike with normal exposure compensation, the *amount* of flash correction is not continuously displayed. The flash exposure compensation symbol remains visible, however, on the LCD and in the viewfinder. If you want to check the degree of flash compensation, recall the function to the LCD by pressing the function button.

The correction remains in place, even if the camera has been turned off, until you reset it to zero (0). Flash exposure compensation affects the built-in flash unit and any EOS-dedicated Canon

Speedlite. But with the Speedlite 430EZ or 540EZ, a correction set on the flash unit takes precedence over one set on the camera.

For total exposure control, flash exposure compensation and ambient light exposure compensation can be combined. This lets you adjust separately the brightness of the flash-illuminated foreground and the ambient-lighted background.

Second-Curtain Flash Sync

With normal synchronization, the flash fires with the opening of the first shutter curtain. With second-curtain sync, the flash fires with the closure of the second curtain, at the end of the exposure. In conjunction with a long shutter speed, this allows the ambient light exposure to blur any movement before the flash illuminates the subject at the end of the exposure. The resulting image corresponds with the natural way we perceive motion. For example, if you use second-curtain sync to photograph a moving vehicle, the headlights create a trail of light and then the flash fires to expose the entire car.

Custom Function C06, setting 1 lets you modify the Elan II/IIE to produce this effect. This approach is not limited to cars, by the way, and is well worth some experimentation. Note that second-curtain sync has no significant effect at normal shutter speeds (higher than about 1/15 second) or with stationary subjects. The second-curtain sync remains set until you change it.

Accessory Flash Units

Serious flash photographers will enjoy the higher power and added features of the Canon Speedlite range of dedicated flash units. The leader of the pack for advanced flash technology is the Speedlite 380EX, introduced with the Elan II/IIE.

Use an accessory flash unit to illuminate subjects beyond the range of the camera's built-in flash or with long focal length lenses. This photograph was taken with a 135mm focal length, which produced just the right framing.

E-TTL Flash with the 380EX

When used with the 380EX, the Elan II/IIE offers a new flash mode called E-TTL. The abbreviation stands for "Evaluative TTL," referring to the camera's six-zone evaluative meter, which is used to coordinate flash and ambient light.

This system is quite different from the TTL and A-TTL flash modes available with the built-in flash and other Speedlite units. These employ the four-zone internal sensor, which reads off the film surface. No matter how carefully the light is measured, there is still the possibility of variations caused by the different reflective properties of various films.

The Speedlite 380EX offers the highest level of Canon's flash technology.

In simple terms, here's how E-TTL works: When you press the shutter release, the Elan II/IIE focuses and uses the six-zone evaluative pattern to measure the ambient light. The 380EX then fires a preflash, which is invisible to the human eye. The flash light reflected back from the subject is measured by the same six-zone sensor, which employs a computer algorithm to compare the relationship between ambient light and flash. The camera then determines the exposure settings and flash duration.

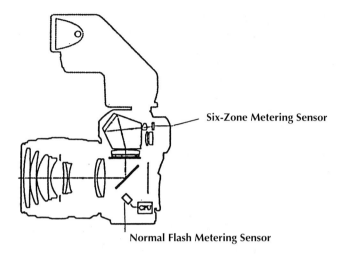

Six-Zone Metering Sensor

Normal Flash Metering Sensor

The six-zone exposure metering sensor located behind the pentaprism also determines the flash exposure in E-TTL flash mode. The normal flash exposure metering cell located on the floor of the mirror box is used for TTL and A-TTL flash control.

Unlike conventional A-TTL, E-TTL measures the reflective characteristics of the subject as well as its distance. The six-zone sensor eliminates variations in readings caused by the film's reflectivity and enables a more precise evaluation of the main subject, as identified by the AF system. The result, independent of the subject's location in the frame, is a natural-looking, uniform overall exposure. And if E-TTL seems like a further refinement of the Elan II/IIE's AIM system, you're exactly correct.

This is the first time the six-zone ambient light metering cell in an SLR has been used to control flash exposure. The operation is "transparent" to the user, requiring no more effort than conventional flash modes. All you do is set the Command Dial to any mode (except Landscape, Sports, or Depth-of-Field AE), turn on the 380EX's power switch, and slide its flash switch to the green (normal) position. Then press the shutter release partway to autofocus on the subject and initiate the E-TTL sequence. In the viewfinder, the flash symbol, shutter speed, and aperture will appear. Finally, push the shutter release down all the way to make the exposure.

The results of E-TTL are well balanced with ambient light and technically accurate for most every exposure. When it's time to buy a flash unit to complement your Elan II/IIE, serious consideration should be given to the Speedlite 380EX.

Other 380EX Features

This compact flash unit's reflector automatically zooms to match the focal length of the lens in use, including 24mm, 28mm, 35mm, 50mm, 70mm, and 105mm settings. As you would expect, the short end fully illuminates the image field of a 24mm wide-angle.

With short focal length lenses, the flash covers a wider angle of illumination but a short maximum distance. With longer lenses, the light is concentrated over a narrower area and has a greater range. Therefore, as the focal length setting changes, so does the guide number. With ISO 100 film, the guide number varies from 69 in feet (21 in meters) at 24mm, 102 in feet (31 in meters) at 50mm, and 125 in feet (38 in meters) at 105 mm. For lenses beyond 105mm, there is no further increase in guide number.

The flash reflector can be tilted from 0° to 90° for indirect "bounce" flash, with full E-TTL control. To save power, the 380EX turns itself off after 90 seconds of inactivity.

When the 380EX is mounted, the AF assist illuminator in the flash and the one in the camera share tasks. If the central AF point is active, the 380EX's illuminator fires, but if another point is active, the camera's AF assist beam takes over.

Custom Function C06, setting 1, which programs the Elan II/IIE's built-in flash for second-curtain flash sync, also works with the 380EX. The unit is compatible with all Canon flash accessories, including those designed for multiple-unit operation.

The 380EX is usually powered by four AA alkaline batteries, providing 260 to 1,800 flashes at recycling times from 0.1 to 7.5 seconds. Slightly faster recycling times of 0.1 to 4.5 seconds are available with NiCd batteries, but only for 75 to 500 flashes per charge. Canon has also approved the use of the new AA lithium cells, which offer an excellent combination of high voltage and long life. Some flash units can be harmed by the higher starting voltage of the lithium batteries, but the 380EX is designed to handle it.

Two particularly interesting features of the 380EX-Elan II/IIE combination are high-speed sync (FP Flash) and FE lock.

High-Speed Sync (FP)

As mentioned earlier, the Elan II/IIE's fastest sync speed is 1/125 second. At faster settings, a slit formed by the two shutter curtains traverses the film to create the exposure. Therefore, a single burst of flash would illuminate only a slice of the image area.

With the 380EX, however, the Elan II/IIE can break through this speed barrier. When set for FP (focal plane) flash, the unit fires a series of "strobe" flashes that synchronize with the moving slit of the shutter. This illuminates the frame completely, with no visual hint of the flash's discontinuous nature. Such prodigious output naturally requires a lot of energy, resulting in a lower guide number and shorter flash ranges.

At 1/180 second—the first shutter speed faster than 1/125 second, and hence the first FP setting—the guide number is 54 in feet (16.6 in meters) with an ISO 100 film and a 50mm lens. (This is about half the 102 (31) guide number for conventional flash with the same focal length.) The equivalent guide number at 1/4000 second is a tiny 12.5 in feet (3.8 in meters). Maximum flash distance also varies with the lens speed; a best-case limit, for a 50mm f/1.4 lens at 1/180 second, is 39 feet (11.9 meters). With slower lenses and/or higher shutter speeds, the range is more restricted.

High-speed sync can be used in the Program AE, Shutter-Priority AE, Aperture-Priority AE, and Manual exposure modes of the Creative Zone. All you have to do is set the sync switch of the 380EX to the high-speed position, signified by an "H" next to a lightning bolt. A similar symbol will appear in the viewfinder.

This mode offers significant advantages for fill-flash portraiture in daylight. You can set shutter speeds faster than 1/125 second and correspondingly larger apertures to throw the background out of focus. Another application for high-speed sync is freezing fast-moving, close objects without creating ghost images from ambient light.

FE Lock

Normal E-TTL flash produces highly accurate results. But if the subject contains a very bright light source or surface, a metering error could result. To prevent this, you can use the FE lock button of the Elan II/IIE to ensure proper flash exposure of the chosen subject. This feature is available in all Creative Zone modes.

Simply aim the central AF point at the subject, press the FE lock

button, and release it. The 380EX emits an invisible preflash, enabling it to determine subject distance and reflectivity. Meanwhile, the designation "FEL" (Flash Exposure Lock) appears briefly in the viewfinder, next to the aperture number. The resulting exposure value is stored for 16 seconds, giving you time to adjust the composition as desired. If you don't take the picture within this period, the FE lock is released.

Custom Function C08, setting 1 lets you link FE lock to a manually selected AF point, or to the Eye Controlled Focus point (on the Elan IIE).

Bounce Flash
The 480EG, 540EZ, and 380EX Speedlites have reflectors that can be tilted and rotated to bounce light off a ceiling or wall. The purpose is to diffuse the output, avoiding the hot highlights and hard shadows produced by direct flash.

Directing the flash diagonally upward at the ceiling, for example, creates a large, soft light source that shines down on the subject. This is far more pleasant than direct flash, and generally prevents the dreaded red-eye syndrome (although shadows sometimes appear on subjects with deep-set eyes).

Bouncing flash off a wall or ceiling diffuses the light and reduces the harsh glare often resulting from direct flash illumination.

Changing the angle of the reflector, perhaps by combining tilt with rotation, varies the apparent location of the light source. It is very important, by the way, that the reflective surface be pure white, without patterns. If not, its color will tint the flash illumination, and hence the subject. (The only exception is a slightly warm

Use a moderately powerful flash unit and bounce the light off the ceiling to illuminate larger rooms more effectively.

white wall or ceiling, which takes the cool edge off the flash light and produces glowing skin tones.)

Keep in mind that light bounced from the flash inevitably travels a long way. It first goes to the wall or ceiling, gets diffused (causing perhaps two stops of light loss), and then is mostly reflected toward the subject. The bottom line is that you wind up using wide apertures and/or fast film. And in a room with a very high ceiling or dark walls, bounce flash just won't work.

The natural-looking effect created by bounce flash is beautiful, but not always desirable. Your main subject may tend to blend into the background, without being singled out by the blast of a direct flash. That's why a combination of direct and bounce illumination is often desirable.

This arrangement can be achieved easily with a flash unit that does not fire a test flash (or allows you to turn it off), including the Speedlite 480EG, 540EZ, 300EZ, and 200EZ. You simply employ

Fill flash is great for daylight shots. It adds catchlights to the eyes and brings out shadow detail. Setting flash compensation to underexpose by 1/2 stop ensures that ambient light is the primary light source and that light from the flash does not dominate and create an unnatural effect.

any of these units normally for direct flash. The second flash unit, which need not be very powerful, should be mounted on a tripod or light stand and aimed at the ceiling or wall. This unit can be triggered by an inexpensive "slave" photocell, which responds instantly to the firing of the main flash.

The amount of light that hits the ceiling is not great, but it should be sufficient to soften the shadows. If the second unit is aimed at the wall, it may kick in more illumination, and so it should be positioned and aimed carefully. If you're truly ambitious, this setup can even be extended to include several bounce units.

Purists (including author GR) use the main flash in its Manual mode and adjust for the extra illumination provided by the fill flash. More relaxed photographers (such as author SP) leave the main unit in its Auto mode and accept the slight increase in density caused by the bounce flash.

Speedlite 480EG

The 480EG is a powerful, handle-type flash unit with twin xenon flash tubes that deliver extremely flat, even illumination. A guide number of 157 in feet (48 in meters) with ISO 100 film testifies to its enormous light output. This unit has an external sensor that permits automatic flash exposure, with a choice of four apertures. Alternately, it can be linked to the Elan II/IIE's internal flash metering system via a cable that connects to the camera's hot shoe.

Canon Speedlite 480EG

An accessory diffusion panel spreads the output wide enough to cover a 20mm lens' angle of view, while a telephoto attachment concentrates the flash for efficient coverage with telephotos of 135mm or more. The reflector can be tilted for bounce flash while retaining automation. Recycle times are 0.2 to 6 seconds with NiCd rechargeables in the Transistor Pack E, and 0.2 to 17 seconds with C cells.

Speedlite 540EZ

This is the most powerful Canon dedicated flash that can be mounted in the Elan II/IIE's hot shoe, with a maximum guide number of 177 in feet (54 in meters) at ISO 100. Its zoom reflector allows the light output to match lens focal lengths from 24mm to 105mm; an accessory diffuser spreads the light to cover the field of an 18mm ultra wide-angle. The reflector can be tilted for bounce flash or pointed down 7° for close-up work.

The 540EZ is controlled by the metering cell in the Elan II/IIE, in the TTL and A-TTL modes. Flash exposure can be fine-tuned in 1/3-stop increments over a range of +/-3 EV, a capability that is

The high-performance Speedlite 540EZ is ideal for the EOS Elan II/IIE.

particularly relevant for fill flash in daylight. Second-curtain sync is possible, as is manual flash output at eight levels from full to 1/128 power.

For special effects, the 540EZ is capable of generating strobe flashes at the rate of up to 100 per second. External power packs, recommended for such power-intensive use include the Transistor Pack E and the Compact Battery Pack E. The standard power source is a set of four AA batteries of the alkaline, lithium, or NiCd type. In fast-recycle mode, the minimum recycling time with NiCd rechargeables is 0.2 to 1 second, or 0.2 to 3 seconds in normal mode.

Speedlite 200E

This very compact flash unit has a guide number of 66 in feet (20 in meters) at ISO 100. Lacking fancy features, the 200E is best regarded as a more powerful version of the Elan II/IIE's built-in flash. For example, with ISO 100 slide film and an f/4 lens, it offers a maximum shooting distance of about 16 feet (5 meters), or 23 feet (7 meters) with negative film.

The fixed, non-bounce reflector illuminates the image area of a 35mm lens, while a wide-angle diffuser spreads the beam enough for a 28mm lens. A built-in AF-assist beam makes it possible to focus in poor light or even darkness at distances of up to 16 feet (5 m).

Macro Ring Lite ML-3

The closer you get to an object, the greater the problem of illumination parallax. In fact, a flash unit mounted in the camera's hot shoe may shoot right past a close-up subject, leaving it in darkness.

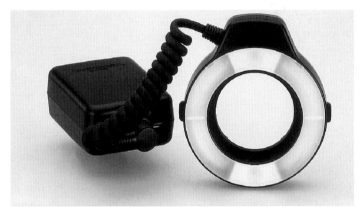

The Canon Macro Ring Lite ML-3

This problem has led to the development of "ring"-type electronic flash units such as the ML-3, with circular flash tubes that mount right on the front of the lens. These models provide even, shadow-free illumination and allow the small working apertures needed in close-up work.

The ML-3 contains two flash tubes, which can be controlled separately to produce flat or directional light. Its guide number is 36 in feet (11 in meters) at ISO 100. This may not seem like much, but consider that the ML-3 is only intended to work over subject distances from about eight inches (20 cm) to 13 feet (4 m).

Like many ring flashes, the ML-3 consists of three parts: a control unit that fits in the Elan II/IIE's accessory shoe, the lens-mounted flash head, and a cable to connect the two. Recycling

times vary from 0.2 to 13 seconds, depending on battery condition, distance, and the subject's reflectivity; flash duration is usually 1/2000 second or less. Power is derived from four 1.5-volt alkaline batteries, which last for at least 100 flashes. The ML-3 is best suited for Aperture-Priority AE or Manual exposure modes, with macro lenses such as the EF 50mm f/2.5 and EF 100mm f/2.8.

Multiple-Unit Flash

Inexpensive "slave" photocells, such as those described in the "Bounce Flash" section, allow you to fire as many flash units as you wish. The tradeoff, particularly if more than two units are employed, is a lack of automation. For more sophisticated arrangements, up to four dedicated Speedlites (excluding the 200E) can be interconnected, making use of the Elan II/IIE's internal metering cell and fully automatic A-TTL flash mode. The following accessories are required:

1. TTL Hot Shoe Adapter 3, which accepts the primary flash unit in the camera's hot shoe.
2. TTL Distributor, which enables up to three additional flashes to be connected.
3. Off-Camera Shoe Adapter for each additional flash. This is essentially a hot shoe mount with a tripod socket and a socket for a connecting cord.
4. Connecting Cords 60 (2 feet/60 cm) and/or 300 (9.8 feet/3 meters), as required.

The Off-Camera Shoe Cord 2 offers greater flash control. This accessory makes it possible to separate the camera and flash.

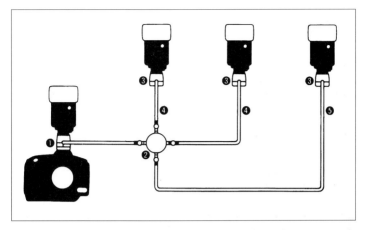

The modular off-camera and multiple TTL flash accessories for use with Canon Speedlites are 1) TTL Hot Shoe Adapter 3, 2) TTL Distributor, 3) Off-Camera Shoe Adapter, 4) Connecting Cord 60, and 5) Connecting Cord 300.

You should definitely experiment with the placement of each flash unit, because illumination from various angles and at different strengths is required to make the subject appear three-dimensional. This can be achieved by using diffusion attachments or by positioning the Speedlites at various distances from the main subject. Note that the auto-zoom feature (which matches the flash's zoom setting to the current focal length) is neither possible nor desirable for multi-flash work.

Flash Tips

Modern technology has made fill flash very easy and well worth using. A finely controlled fill light can create catchlights in the model's eyes and add detail to parts of the face that would otherwise be dark. It should be subtle enough to complement, rather than overwhelm, the existing daylight, maintaining the basic pattern of highlights and shadows.

Brightening the foreground illumination in poor ambient light is a more delicate matter. The dull natural light produces weak shadows, which are easily overpowered by fill flash. But these

half-shadows are precisely what gives the subject dimension; without them, everything looks flat. So add fill sparingly, perhaps experimenting with the flash exposure compensation feature to tone it down by various increments.

Whenever you use flash, keep in mind that light intensity falls off drastically, even over the span of a few yards. The unintended result may be that a close subject is overexposed, while a more distant one remains murky. The Elan II/IIE calibrates flash exposure for the subject at the active focusing point—for example, a group of friends seated at a table 10 feet (3 m) from the camera. The white tablecloth and army of bottles in the foreground will receive far too much light from the flash and appear as distracting white blobs in the image.

So a trustworthy rule of direct-flash photography is to illuminate subjects at a single distance. A buffet table that stretches from the foreground into the background just can't be lit by a single, on-camera flash. As we have seen, the front will be too bright, and the back too dim.

Comparatively powerful accessory flash units often make it possible to use small apertures. This produces extensive depth of field, which may in turn create distracting backgrounds. Pictures of people with plants growing out of their heads or picture frames on their ears tend to be rather unflattering. You can easily avoid such predicaments by carefully examining the viewfinder image and changing the camera's position as needed. Moving it a bit to the side, somewhat higher, or (preferably) a little lower, can put their heads in the clear.

EOS Elan IIE QD

The Elan IIE is available in a QD (Quartz Date) model that includes a data back. So when deciding on which Elan model you want to buy, you will have to decide in advance whether you are ever going to want to identify your photographs with a date, day, or time. The possibility of printing dates on your photos can increase the camera's versatility and make sorting your pictures much easier. On a vacation trip, for example, it will establish exactly when you visited the Parthenon. And if (God forbid) you have two Christmas holidays on one roll of film, you'll know which is which.

For serious photography, however, the date feature is less useful. Artistic images seldom benefit from having small reddish-orange numbers in the corner of the frame. And if your memory needs a jog, many photo labs print the processing date on every slide frame or on the back of every print. In any case, the QD back can be bypassed by pressing the mode button. Once the mode is set, it remains in that mode until you change it. You do not have to enable or disable the data print feature before each individual exposure.

A built-in quartz clock automatically calculates short and long months, as well as leap years. It is programmed to the year 2019 and offers various date styles, such as the ever-popular month/day/year; year/month/day; day/hour/minute; day/month/year (and blank, of course!). A 3-volt CR2025 lithium cell powers the data back, with a life span of about three years. It can be replaced easily when there is no film in the camera.

An LCD on the back of the Elan IIE QD displays the data that will be added to the frame. For horizontal shots, the digits appear in the lower right-hand corner of the frame. For verticals, the position of the data depends on the orientation of the camera. With the shutter release to the top, they appear in the top right corner, floating prominently in the sky or in your subject's hair. Better to hold the camera with the shutter button near the bottom, making the date show in the lower left-hand corner of the frame. In this orientation, the camera lies on your right palm, and your right thumb operates the shutter release.

With the Elan IIE QD, the date can be printed in the bottom right-hand corner of the picture. Here, the option day/month/year was selected.

For maximum legibility, the area behind the date should be as dark as possible. Be careful to avoid reddish backgrounds, which may render the numbers difficult or impossible to read.

Canon Accessories

The Elan II/IIE's features are so comprehensive that the list of its accessories is limited. Since few photographers need everything, keeping some features separate from the camera reduces stress on the wallet and the gadget bag.

Battery Pack BP-50

The Battery Pack BP-50 has a shutter release button located conveniently for vertical shooting.

This item performs two functions. One is to serve as an alternate power source, containing four AA or NiCd batteries, or a 6-volt 2CR5 lithium cell. The BP-50 also functions as a convenient vertical-format handgrip, complete with a shutter release and a power on/off switch. If you like the grip but want to save weight, you can even use the BP-50 without batteries, working off the lithium cell in the Elan II/IIE.

High-Capacity External Battery Pack BP-5B

When used with the BP-50, the BP-5B offers extended shooting capabilities without the need to change batteries. It accepts four D-size alkaline cells, with a total capacity more than eight times that of the camera's lithium battery. The added juice is especially welcome for cold-weather shooting, which is brutal on batteries. If you prefer, D-size NiCd rechargeable cells can also be used.

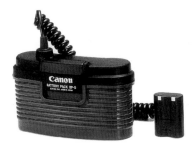

The High-Capacity External Battery Pack BP-5B requires the Battery Pack BP-50.

The BP-5B fits on your belt. It attaches to the Elan II/IIE with a coiled cord that slips into the camera's battery compartment.

Remote Controller RC-1

The Elan II/IIE is equipped with a remote control sensor. To use it, however, you have to buy the RC-1 wireless remote control emitter. As a bonus, this device also activates the camera's self-timer and mirror lock-up functions. It operates at a range of up to 16.4 feet (5 m).

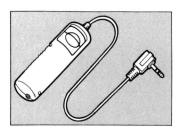

Remote Release Cable RS-60E3

Remote Switch RS-60E3

Those who frequently shoot from a tripod or copy stand should spring for the RS-60E3 (or the RC-1). This wired remote switch significantly reduces the danger of camera shake during long exposures. Then all you need to make the Elan II/IIE perfect for close-up photography is to set Custom Function C05, setting 1 to lock up the mirror during self-timer operation.

Dioptric Adjustment Lenses Ed

These new eyepiece adjustment lenses attach to the Elan II/IIE's viewfinder and include their own rubber frames. Ten strengths are available, from +3 to -4 diopters, enabling far- and nearsighted photographers to work without eyeglasses. Best of all, the Elan IIE's Eye Controlled Focus features are fully functional with Ed lenses. Before you purchase one, however, make sure that it suits your vision.

Close-Up Lenses

The simplest and cheapest way to do close-up photography is with add-on accessories that screw into the lens' filter thread. These lenses do not affect exposure or autofocus operation.

Canon offers high-quality close-up lenses in three series and several sizes, a range that was not previously available from any manufacturer. The first series is the 250D, a two-element achromatic design supplied in 52mm and 58mm screw-on sizes. Canon recommends that these professional-quality lenses be used with focal lengths between 38mm and 135mm.

The second series is the 500 single-element type, available in 52mm, 58mm, 72mm, and 77mm sizes. It is recommended for lenses with focal lengths from 70mm to 300mm.

The third (and most interesting) series is the 500D, a two-element achromatic design similar to the 250D, but with less power. The sizes and focal length recommendations are the same as for the budget-priced 500 series.

As you may have guessed, the model number for each series

A close-up lens can be attached to your lens to make beautiful close-ups like this. There's no need for you to buy an expensive macro lens.

represents the camera-to-subject distance in millimeters, with the prime lens set at infinity. Note that attaching more than one close-up lens is *not* recommended, as the additional weight would cause slow focusing, and might even harm the AF motor.

Camera Case

Canon offers the Camera Case EH9-L, which is just large enough to hold the camera with a lens no longer than the EF 28-105mm f/3.5-4.5 USM mounted. The case can be purchased separately and mounts on the base of the camera.

This case is appropriate for the photographer who owns only one lens or is traveling light on an arduous hike. The equipment is protected (but not as well as in a padded bag), and the front of the case drops down for quick shooting.

Dinosaur Habitat

Habitat

HELEN V. GRIFFITH

Dinosaurs
rule the
earth...and
you are
there!

ILLUSTRATIONS BY SONJA LAMUT

US $4.95 / $7.50 CAN
ISBN 0-380-73225-4

He felt like a rock star as the crowd cheered his unprecedented victory.

Meanwhile, Word Paynn sat back in his chair and gloried in the moment for another reason. With Moordryd as the leader of the Down City Council, Word's master plan could now continue without delay.

The glory was short-lived. From out of the shadows, another figure seated on a dragon rode out to the center of the track. As the crowd took notice, the cheering melted away, replaced by stunned silence.

"Wait a second!" the Dragon Booster called from his position on top of Beau.

Even Word Paynn was surprised. "The Black-and-Gold Dragon of Legend!" he gasped. Until that moment, he had not

seen the dragon with his own eyes. He had only heard about it from Moordryd's descriptions. The creature was even more magnificent than he had imagined. Seeing the creature standing before him set Word's mind reeling. His thoughts were shattered by the Dragon Booster's next words.

"According to the ancient laws, there can be one more challenge today," the Dragon Booster announced. He looked directly at Moordryd.

"I challenge you, Moordryd Paynn!"

CHAPTER 7

The Dragon Booster's challenge broke the silence. Cheers, shouts, and protests filled the air.

"Silence!" Phistus yelled. "This Dragon Booster has the legal right to challenge!" Phistus's words had little effect on the crowd, but they bothered Moordryd. After his previous encounters with the Dragon Booster, Moordryd wasn't looking forward to the possibility of yet another embarrassing episode. But a voice whispering in

his ear quickly changed his mind.

"Moordryd, this is the chance we've been waiting for," Word whispered through his son's comm link. "Listen to me. We have a change of plans."

As Moordryd listened to his father's idea, his mood brightened considerably, and a sly smile streaked across his face.

"The crowd is waiting, Moordryd," said Race Marshall Budge.

Lance and Parmon looked on eagerly from their hiding places on the side of the jousting arena. This was the moment they had been waiting for. They knew how much time Artha and Beau had spent preparing for an event like this, and they knew there was no way anyone could defeat them—at least they were pretty sure there wasn't.

"Not so fast," Moordryd said. "I not only accept your challenge, Dragon Booster, but I will up the ante. The winner takes control not only of the Down City Council, but of the loser's dragon as well!"

The crowd gasped at this unusual challenge. Even Lance and Parmon, who had been so confident, exchanged a worried look at the bold announcement.

"Will Artha really risk losing Beau?" Lance asked Parmon.

"Only one way to find out." Parmon shrugged. He and Lance stared at Artha, waiting for his answer.

"Accepted!" the Dragon Booster replied.

From his spot in the stands, Word smiled and sat back in his chair, once again

confident that his plan would succeed.

Ever the worrier, Parmon scanned the jousting arena with his binoculars. "Something tells me we may be in for more than we bargained for," he said. As his gaze swept across the far end of the track, where the Dragon Booster and Beau were getting ready, Parmon saw something in the shadows behind them. Something that shouldn't be there. He gasped.

"Artha! We have a problem! You can't joust," Parmon called through the comm link.

"Can't joust?" Artha replied. "Funny, Parm, very funny."

"I'm serious, Artha," Parmon said urgently. "There's something stalking you

. . . and it appears to be invisible. My binocs are reading something huge . . . ten tons at least . . . twenty meters."

Artha's mood quickly darkened. "Where? *Where?*" he asked, looking around the arena.

Parmon searched without his binoculars and then again with them. The image of the Wraith Dragon became clear in his heat-sensing binocs.

"It's right behind you," Parmon said.

Artha looked again. "I don't see anything, Parm," he reported.

As Parmon adjusted the settings to get more information on the creature, a jet of sparks shot out from the control wheel.

"What was that noise?" the Dragon Booster asked.

"My binocs are fried," Parmon said, frustrated. "Now I don't know where that creature is!"

The Dragon Booster stared down the track at Moordryd, trying to stay focused on the joust. He wished Parmon's invention hadn't picked now to get fried.

"It's time for the first round," Race Marshall Budge announced. "Same rules as before!"

Parmon frantically tried to repair the binoculars before the jousting began. Lance watched Race Marshall Budge pick up the gong.

"Oh, no!" Lance cried. "The race is going to—"

The sound of the gong echoed through the arena.

"—Start!" Lance gasped.

Beau and Decepshun started down the track toward each other.

Lance clutched his toy dragon with the makeshift jousting stick attached.

"I'm getting creeped out, Parm," the Dragon Booster said through the comm link. "Where is that thing?"

No sooner had the words left his mouth than the Wraith Dragon rammed itself against Beau.

"Never mind, it found me!" he added as he tried to regain his balance. But it was too late. Moordryd Paynn was ready to strike and knocked the Dragon Booster clean off Beau.

Parmon and Lance cringed as the Dragon Booster slammed down on to the

track. Beau skidded to a stop up ahead and ran back to Artha's side. As Artha stood up, both he and Beau felt the wind of the Wraith Dragon as it whisked by.

"Parm, if you don't do something fast, I'm going to lose everything!" Artha said.

CHAPTER 8

Things were not going well for the Dragon Booster or Beau. Artha took stock of his situation and realized that one tiny mistake could cost him the joust—and Beau. Not to mention the fact that it would mean giving Moordryd legitimate control of the council. Maybe he had been foolish to accept Moordryd's challenge, but what choice had he had? He couldn't let Moordryd take control of the council. Right now, the Dragon Booster knew that

he needed a plan, but all he had was a best friend whose thermal-imaging binoculars were broken.

"Any . . . second . . . now . . ." Parmon said through the comm link as he feverishly tinkered with the binoculars. Finally, the image inside the gadget flickered back to life. "Yes! They're working, Artha! They're working!"

The Dragon Booster took a deep breath and climbed back on to Beau. The two of them made their way slowly back to the far end of the track. Artha wanted to buy Parmon as much time as possible before the next joust.

Parmon adjusted the binoculars and sharpened the image. He studied the mysterious form.

"I can see it better now, Artha," he reported. "It's a dragon covered in control gear. But there's no rider."

"I'll bet it's remote-controlled!" Lance exclaimed. That would be totally drac.

"That gives me an idea, Lance," Parmon said. He opened up the vid controller that he used to communicate with Artha and began wiring it to the binoculars. Lance watched closely.

"If I can just wire the binoc-frequency modulator to the vid-control transmitter, then I can—"

"—Take control!" Lance added.

Parmon shook his head. "Well, not exactly, but if I send out a signal on every available frequency," he said, "maybe I can jam whoever does have control!"

The wheels inside Lance's ten-year-old brain began turning. He held up the remote-control device for his toy dragon.

"One moment, Lance," Parmon said.

"But—" Lance began.

"Lance! Not now!" Parmon scolded. He tried to transmit the jamming signal.

Artha and Beau continued to move as slowly as they could.

"Dragon Booster? Do you wish to be disqualified?" Race Marshall Budge asked. He was hoping to speed things up a bit. Budge didn't want the audience to grow bored.

Artha knew he was out of time and moved Beau into position. He turned to face Moordryd. Both riders raised their jousting poles.

With one hand working the dials on his controller, Parmon used the other to hold the binoculars to keep an eye on the invisible dragon. He watched the mysterious dragon quiver, convulse, then fall to the ground.

"I did it, Artha, I did it!" Parmon cried gleefully.

Hearing Lance clear his throat, Parmon looked down to find the boy smiling at him. Lance was holding his remote-control antenna against Parmon's wiring. When Lance moved the remote-control device away, Parmon checked the binoculars again. The Wraith Dragon recovered and leaped to its feet. When Lance touched the antenna to the wire, the dragon trembled and collapsed again.

Lance repeated the experiment two more times before Parmon got the message.

"Uh, Artha—that is, uh, Lance—did it," Parmon said.

"That's right, Lance did it!" cried the boy.

"You're ready, Artha!" Parmon said, with a smile to Lance. "Now, go get him!"

Race Marshall Budge struck the gong, and round two of the joust began. As Moordryd and the Dragon Booster raced toward each other, Cain worked his remote-control device. He began to panic as the dragon remained lying on the ground, twitching. Without help from the Wraith Dragon, Moordryd was completely out of his element.

"What's going on, Cain?" Moordryd

called through the comm link.

But before Cain could reply, the Dragon Booster and Beau delivered an answer of their own, pummeling Moordryd with a fierce blast.

"Great work, guys," Artha said into his comm link.

Moordryd flew off Decepshun and through the air and skidded along the track. He sat up in disbelief.

The crowd cheered wildly. Phistus smiled in satisfaction. Word, however, was not pleased. His displeasure quickly boiled over into rage. He reached into his cloak and took out a pair of the special yellow glasses. One glance at his dragon told him everything he needed to know.

"Moordryd, the Wraith Dragon is

down!" he said. "Do something!"

"Cain, do something!" Moordryd ordered.

Cain frantically worked the controls, to no avail. "I'm trying, I'm trying," he replied. "But this stupid thing won't work!"

Thinking that maybe the dragon was out of range of the remote, Cain stepped from the shadows. He shook the remote and banged it against his hand.

The activity caught Lance's attention.

"Hey, Cain's got a remote, too!" he said.

Parmon looked over.

"I'll bet he's the one controlling that thing down there," Lance said.

"Not anymore," Parmon replied. "That *thing* is out of commission."

As if on cue, the delicately wired con-traption in Parmon's hand suddenly sparked and fizzled.

"Oh, no!" Parmon cried. He looked through the binoculars and saw the dragon get back up again. "Artha! Our transmitter is toast! We lost our jamming signal!"

Meanwhile, Cain found that the unit in his hand was suddenly working again.

"Wait a sec!" he told Moordryd. "We're back on line!"

Race Marshall Budge's voice once again filled the air: "Riders, prepare to joust again!"

A feeling of panic began to take root in Artha's stomach. "Parm, do something!" he begged.

"I'm trying, Artha!" Parmon answered,

his full attention focused on repairing the jammed device.

It was too late. The gong rang out for the next joust.

The jousters hurtled down the track. The Dragon Booster tried to ready himself for the Wraith Dragon's blow, but nothing could have prepared him for the force of the blast. The invisible dragon struck Beau

with such power that pieces of Beau's gear flew into the air. Artha was knocked senseless, but his body didn't fall to the ground. It dangled from Beau's saddle like a rag doll. Artha drifted in and out of consciousness and slowly began to slip out of the saddle.

Word was most pleased with the result. It's just a matter of time before I rule now that the Dragon Booster is finished, he said to himself.

CHAPTER 9

"Fall! Fall! Fall!" the crowd chanted.

The Dragon Booster dangled from the top of Beau's back. With his last drop of energy, Artha instinctively grabbed hold of whatever he could find, which happened to be a piece of Beau's racing gear. The sounds of the crowd rushed into Artha's ears. Then, slowly, another sound began to replace that of the crowd. It was Lance's voice.

"Artha, please!" Lance called out.

"Remember what Mortis said. If there's one lesson you must learn, it's . . ."

Lance's voice quickly melded with Mortis's voice and filled Artha's head.

". . . It's to know the true meaning of *heart*, and to never give up!" Mortis said.

Artha drew strength from the words and opened his eyes. Ounce by ounce, he rebuilt his resolve and slowly pulled himself back up. This display of willpower silenced the crowd and gave Beau a second wind. The black-and-gold dragon began to tremble. As Artha righted himself in the saddle, his energy flowed to the Gold Star–Mark on Beau's head. The Dragon Booster and Beau generated a massive burst of glowing green-draconium energy.

"This Dragon Booster truly has the strength of a hero," Phistus said from his spot in the stands.

The crowd went absolutely wild.

"AMAZING!" Race Marshall Budge shouted. "Again! Until one falls!"

Moordryd scowled as he returned to his starting position.

"Cain, let's get this over with already!" he said.

The Dragon Booster and Beau made their way back to their starting point.

"Parm, I'm not going to survive another hit from that thing," he warned.

"I'm trying, Artha, I'm trying," Parmon said. More sparks flew from the vid controller. "Lance, we must find a way to help Artha!"

Lance looked at Artha, then at Cain, and then back at Parmon. He reached up and snatched back his remote control.

"Hey, I need that!" Parmon said.

"There's no time!" Lance said.

He placed his toy dragon on the ground.

Race Marshall Budge hit the gong once again.

As Beau and Decepshun took off, Lance activated the remote and sent his own toy dragon racing away.

The Dragon Booster and Moordryd barreled down the track, their jousting poles in position.

Lance matched his jousting pole's position to that of the Dragon Booster's pole.

The real dragons closed in on each

other as Lance's toy dragon closed in . . . on Cain. The toy dragon surged forward and stuck its weapon right into Cain's leg. The surprise of the impact, coupled with the stabbing pain caused by the stick, caused Cain to jump back and let go of the vid controller. The device crashed to the ground and broke apart.

The Wraith Dragon slowly appeared before the crowd.

"What in the world . . . ?" Race Marshall Budge exclaimed.

The Wraith Dragon, now fully visible to everyone in the arena, bumped Beau. Once again, Moordryd managed to send the Dragon Booster flying from his dragon and on to the track.

Beau turned and roared ferociously at

the Wraith Dragon. The Wraith Dragon quickly fled in the opposite direction.

"What is that thing?" Race Marshall Budge demanded. "Who is responsible for this?"

Silence filled the arena. Word quietly slipped out of his private box as Budge stared down at Moordryd.

"Don't look at me!" Moordryd said. "I've never seen that thing before in my life!" He threw an angry glare at Cain.

"Cheating at joust?" Budge asked.

"Cheating?" Phistus echoed. "It is my duty to award tonight's victory to . . . the DRAGON BOOSTER!" Budge announced. Lance and Parmon high-fived each other as the crowd cheered the new champion. Phistus turned away in disappointment.

The Dragon Booster got to his feet and quieted the crowd.

"Phistus was cheated in the same way I was, so my first and only action as council leader is to return the leadership back to him!" the Dragon Booster declared.

Phistus looked on, somewhat bewildered by the Dragon Booster's words.

"What? I object!" Moordryd shouted. "Phistus is not fit to lead! Have we all forgotten about his crew's little bank heist?"

"Lies!" Phistus replied. "There's no proof of this!"

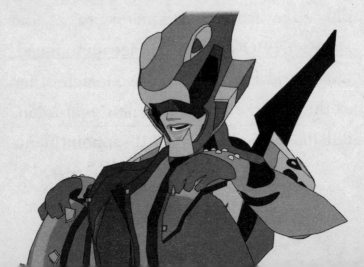

Hearing Phistus's declaration, the Dragon Booster reached into his armor and took out the folded-up jacket he had found in the ventilation shaft.

"Actually, there is this jacket, found on the robber's escape route," said the Dragon Booster. He held up the jacket, with the Grip of the Dragon emblem for all to see.

"There, you see? Guilty as charged!" Moordryd said.

"Somebody tried to frame Phistus for that robbery," the Dragon Booster said, ignoring Moordryd. He tore off the Grip of the Dragon patch, revealing a Dragon Eye emblem sewn onto the jacket underneath. "Somebody from *your* crew, Moordryd."

The game was up. Moordryd had failed.

"I'll, uh, look into that," he said. "I guess

you're still in charge . . . for now."
Moordryd and Decepshun skulked away
into the shadows.

The Dragon Booster stood beside
Phistus. "He is innocent and still the right-
ful leader of the Down City Council!" the
Dragon Booster announced.

As everyone cheered for Phistus, the
leader turned to the Dragon Booster. "You
have great strength and great honor," he
said. "The Down City Council could use
someone like you, Dragon Booster."

"I think they're just fine with the man
they've got," said the Dragon Booster.

Phistus smiled, and he and the Dragon
Booster knocked fists. Then Phistus gave
his new friend a hearty pat on the back.
But Phistus was bigger than the hero. His

pat sent the Dragon Booster flying. It was the perfect end to the joust.

A few moments later, Artha made his way over to Parmon and Lance.

"How did you ever find the strength to keep getting up, Artha?" Parmon asked. "You were getting pummeled out there."

"I couldn't have done it without you guys," Artha said.

"The team!" Lance added.

"Especially you, Lance," Artha said, tousling his brother's hair. "You saved the night. I think your joust with Cain was the biggest joust of the tournament!"

Lance beamed up at his brother. That was just what he wanted to hear.

As the three turned to go, Lance remembered something: "My toy dragon!" he said.

Lance activated his remote control to bring the dragon back to him.

The dragon, which was still standing in the spot where it had jousted with Cain's leg, circled around Cain, who was being yelled at by Moordryd. Then the dragon raced forward, running over Moordryd's foot before zooming back to Lance.

"Who did that?" Moordryd cried. "Who did that? OUCH!"

Artha, Lance, and Parmon laughed their way out of the jousting arena. Even Beau appeared to enjoy the moment. The Dragon Booster team had defeated Moordryd . . . again.

What if you suddenly found yourself in a Jurassic world of colossal reptiles, giant insects, and a smoking volcano? Ryan wants to stay forever. Nathan would go home NOW, if he could only figure out how. In the meantime, some of the dinosaurs have plans of their own for the two brothers. And the volcano looks ready to blow!

"Time travel, dinosaurs, and two feisty brothers combine to offer a fast-paced adventure story . . . that provides excitement, laughter, and thrills . . . A great read-aloud." *SCHOOL LIBRARY JOURNAL*

AVON CAMELOT

PUBLISHED BY
AVON BOOKS
008-012

US $5.75 / $7.50 CAN
ISBN 0-380-73225-4

0 46594 00495 6 73225

www.avonbooks

COVER ART: SONJA L

Dragon Booster

OPPOSING FORCE

Adapted by JAMES GELSEY

Read all the books about

Parmon Sean watches the Dragon Booster through a pair of special binoculars. He is helping the Dragon Booster catch the bank robber.

Lance wants to help, too! From his perch on top of his dragon, Fracshun, Lance tells the Dragon Booster where to go.

The Dragon Booster and Beau are in hot pursuit of a bank robber. When a sign starts to fall to the street, the Dragon Booster stops the chase and saves the day.

Following Parmon's advice, the Dragon Booster jumps down a large pipe. He falls headfirst into an underground tunnel.

The Dragon Booster picks up a racing jacket with the Grip of the Dragon symbol on it. It looks as if the bank robber has left behind a clue!

The members of the Down City Council have gathered at the round table. They have an urgent matter to discuss—the Dragon Booster.

Moordryd Paynn—one of the most ruthless racers in Dragon City—confronts Phistus, leader of the Down City Council. Moordryd wants the council to get rid of the Dragon Booster.

When Moordryd challenges Phistus to a joust for control of the council, the leader accepts. With a mighty cry, Phistus throws down his hammer.

The Black-and-Gold Dragon of Legend comes to the rescue!

Word Paynn has a plan to start another dragon-human war. But he needs his son, Moordryd, to help him, by jousting with Phistus.

Moordryd comes face to face with his father's newest creation—the Wraith Dragon. Word Paynn hopes to take Phistus down with this invisible dragon.

Moordryd and Phistus prepare to joust. Whoever wins will gain control of the Down City Council.

The Wraith Dragon and the Dragon Booster must battle. It is a difficult fight.

Powerful dragons,
racing crews,
adventure, and the
power to change
the world . . .

Get ready to
Release the Dragon!

Phistus is the leader of the powerful Down
City Council. If Word and Moordryd's plan
work, they will take over the council. The
Dragon Booster has to act fast and with
great skill. It is up to him and Beau to save
all of Dragon City before it's too late.

$4.99 US / $6.99 CAN

an imprint of
HYPERION BOOKS FOR CHILDREN

007-010
www.dragonbooster.com